# Ghosts, Traditions and Legends of Old Lancashire

## Ken Howarth

**Published by Sigma Leisure** – an imprint of
Sigma Press, 1 South Oak Lane, Wilmslow, Cheshire SK9 6AR, England.

**British Library Cataloguing in Publication Data**
A CIP record for this book is available from the British Library.

**ISBN:** 1-85058-347-1

**Typesetting and Design by:** Sigma Press, Wilmslow, Cheshire.

**Cover design:** *Pendle Hill by Night;* illustration commissioned by Sigma Press and produced by Martin Mills

**Printed and bound by:** Manchester Free Press

# PREFACE

Many of the stories, traditions and legends found in Lancashire have their origins in Celtic and Scandinavian cultures. These old stories have suffered the ravages of time, not all tales are rooted in the ancient cultures, some are surprisingly very modern indeed - such as the Jumbo story from Manchester Airport.

So many of the region's traditional customs ended with the coming of the two world wars. Men serving abroad were less influenced by tradition, and women had been exposed to different work environments, attitudes and cultural values. Radio and Television successfully erased a great deal more, yet, arguably kept one of the greatest cultural assets alive without realising it - that of story-telling - in the form of the illustrated stories of Coronation Street, and EastEnders.

Many of the early traditions and legends were recorded by Harland and Wilkinson in various publications during the 19th century, it is to these original works that the author has constantly referred. Harland and Wilkinson were not always accurate, but they did at least record a fascinating account of Lancashire's past. The original books are now rare and I am grateful to the many librarians and archivists who entrusted their precious volumes to me during my research.

Not all the information came from books. Much came from my private oral history recordings and from the field work undertaken by David Service of Slaidburn on my behalf.

An analysis of the geographical occurrence of stories, traditions and legends is interesting. Although there are some stories from the cities, they are few and far between. Without doubt the greatest concentration of stories and legends comes from the Ribble Valley, Clitheroe, Pendle and east Lancashire around Burnley, Nelson and Colne. The reason for this is probably that these areas remained rural and traditional for far longer. They were essentially farming communities, retaining their old

values and styles of living. Even with the development of the large cotton towns in east Lancashire, traditions were slow to die away and are still perpetuated but nowadays in the interests of tourism.

I started collecting stories of Lancashire's ghosts, traditions and legends over twenty years ago, and although there is a goodly selection in this book, I have no doubt that many more are waiting to be discovered.

If you have a story, a legend, a tale handed down in the family, a ghost story, then I would very much like to hear from you.

*Ken Howarth 1993*

*Sabden, Pendle Hill*

# CONTENTS

# LANCASHIRE GHOSTS

Lancashire has its fair share of ghosts and ghouls, both ancient and modern. Many are simply stories to be told time and time again on dark nights, but others send a shiver down the spine and a doubt into the mind on the warmest of summer days.

## BOLTON'S HAUNTED BINGO HALL

The old ABC cinema on Churchgate at Bolton was the site of several strange occurrences. Several of the employees sensed and saw things which disturbed them greatly. One lady said *'it felt as though someone was leaning on her'* and another lady felt a tap on the shoulder, on turning round no-one was there. There were various stories about the ghost's origins, the most likely explanation being that it was the ghost of a former projectionist who committed suicide in the projection box by hanging himself.

Whatever the truth, the ghost never really harmed anyone and has restricted its haunting to smashing a few glasses in the bar from time to time.

## THE HAUNTED BUS

The number five late night bus was ready to leave Piccadilly Bus Station in Manchester for Cheadle. There were few people on board and only one upstairs, a man in a light blue coat. The bus journeyed on into the night. The conductor went upstairs and the man asked if the bus went to Cheadle and what was the fare. The conductor told him the fare was 50p and the man paid up.

Eventually the bus reached the terminus and the downstairs passengers got off. Both the driver and the conductor could hear the man moving around on the top deck of the bus. The time came ready for the return

run into Manchester and the conductor went on top, only to find the upper deck completely empty.

## THE CAKE SHOP GHOST

In 1976, Hansford's Cake Shop in Gortoncross Street, Gorton, Manchester was due to be demolished, when the haunting started. A reporter for BBC Radio Manchester was sent to investigate. In a remarkable recording now preserved in the region's archives, the knocking of a ghost can clearly be heard as the reporter made his way into the shop. According to the two ladies running the shop, the haunting started when one of them decided to empty an old cabinet. A knife came through the air, narrowly missing them; one of them was hit by a cream cake on the back of the head whilst she was serving customers in the shop. Pies and cream cakes were sent flying about and on one occasion a man called to repair shop scales was hit on the head by a hot-pot pie.

The two women were genuinely frightened and concerned. They brought in a minister of religion and holy water was also sprinkled. It was only ended when the protesting ghost was laid to rest not by religion but by a bulldozer.

## THE GHOSTLY NIGHTWATCHMAN

Jack Douglas, the actor and comedian, along with Keith Harris, were playing in 'Cinderella' at the Tameside Theatre in 1978. One evening, as they were about to leave the theatre they saw a figure at the back of the stalls, a nightwatchman, beckoning to them. So assuming that it was probably a caretaker telling them to leave by a certain door they made towards the man. They got about 15 feet away when, *'in front of our eyes it disappeared'*.

They were not the first to see and hear things, on one occasion another person thought that he had knocked someone down outside the theatre, but there was no-one there to be found. There have been ghostly footsteps on stage and, according to popular legend, it is the ghost of a person who hanged himself in the theatre many years ago.

## DRABBLE'S HOUND

In 1825 a Manchester trader named Drabble was one winter's night, near the site of Manchester Cathedral when he heard a sound. Suddenly, a headless hound appeared and moved towards him. Before he could react, the hound had placed its paws on his shoulders and *'ran him home at a terrific rate'*.

The headless hound haunted Manchester in the early 1800s, terrifying many local people. It is said to have been laid to rest *'under the dry arch of an old bridge across the Irwell on the Salford side of the river'*.

## THE GHOST COACH OF LIVERPOOL

The story is told that sometime during presumably the 19th century 'several young infidels' used to meet every night and drive in their coach out to the suburbs of Liverpool. Being wild and young, they soon became involved in 'orgies' and drinking bouts. They eventually went too far and burnt a Bible *'and plunged into other forms of dissipation'*. These young men certainly seem to have had a lasting effect on the places they visited, *'still on the hour of midnight a spectre coach stops at their old abodes. Drivers have expected to collide with it, dogs howl and are frightened at its approach, and many have heard, but none seen the spectre coach'*.

## THE GHOSTLY HIGHWAYMAN

The Punch Bowl Inn, at Hurst Green near Clitheroe, was said to be the headquarters for the highwayman Ned King, the scourge of the district. He was captured in the Punch Bowl following a daring raid and promptly hung on the local gallows. For some years, there were moanings and knockings in the Inn, all attributed to Ned King, the highwayman.

## SPEKE HALL AND THE WHITE LADY

In times gone by, Speke Hall must have been truly beautiful, situated on the un-polluted shores of the River Mersey with extensive open range all around. Today, it is sandwiched between Liverpool Airport and various industrial sites, yet it is a gem of the highest quality. It is said that a lady after giving birth to her child at the Hall, found she faced financial ruin because of her husband's recklessness. Presumably in a fit of post-natal

depression, she threw her child from the Tapestry Room window into the moat. She then ran down through the Great Hall and took her own life. Her ghost is said to have been heard from time to time by the staff at the Hall.

## THE GHOSTLY MAYOR OF ST MICHAEL'S-ON-WYRE

St Michael's-on-Wyre is a quiet place, certainly not the kind of place you might have expected to meet a rather wild ghost. Yet, in times gone by, the ghostly spirit of Major Longworth was to be seen parading near the site of his old home, banging doors and using the crockery in a meaningful way. This 17th century ghost became more troublesome and was eventually, following the intervention of the local clergy, laid to rest near the village.

## THE BALLAD OF SIR BERTINE

Sir Bertine was a famous Lancashire Knight who was killed at St Albans during the War of the Roses. Whilst he was away fighting, strange things were happening back at home near Rochdale. The great bell of the Hall suddenly began to ring 'unaided by human hand'. Fingers tapped against the windows, the sound of heavy footsteps was heard on the stairs and in nearby rooms, and on the third day of these strange goings-on, an old man appeared holding the bloody signet ring of Sir Bertine saying that the Knight had been killed in battle and was buried at in the priory at St Albans. (c.1455)

## THE GHOST OF SYKES LUMB

Sykes Lumb farm was situated on the banks of Mellor Brook near Samlesbury. The last farmer was rumoured to have accumulated a large fortune from various sources. The story is set around the time of the Wars of the Roses. Old Syke's wife, afraid that the riches would be seized by itinerant soldiers, placed the treasure in several earthenware jars and hid them beneath the roots of an apple tree in the orchard. In time both of them died. Their relatives searched thoroughly for the jars without success. The years went by and occasionally the ghostly figure of Old Syke's wife could be seen in the area of the old orchard. One of farms occupants after a good night out, asked her what she wanted. She simply pointed to the stump of the old apple tree. A search was made

and the treasure uncovered, Old Syke's wife watching over the proceedings all the while. As the final jar was recovered from the ground, a ghostly smile appeared on her face and then she disappeared forever.

## SAMLESBURY HALL & THE LADY IN WHITE

Samlesbury Hall today lies at the very edge of the main Blackburn to Preston road, sandwiched in by the runway at British Aerospace close by. The building is still splendid and well worth a visit, but in times gone by, the area must have been very different indeed, with extensive woodlands reaching down to the river Ribble some miles away.

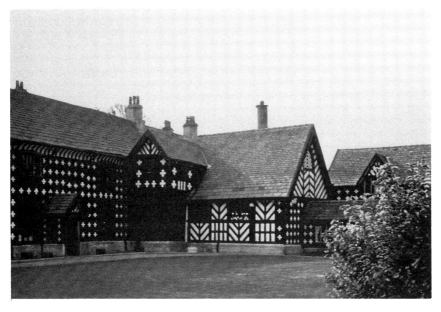

*Samlesbury Hall*

One of the daughters of Sir John Southworth, formed 'an intimate acquaintance' with the heir of a neighbouring house. Sir John however, would hear nothing of a proposed marriage saying that 'No daughter of his should ever be united to the son of a family which had deserted its ancestral faith'.

However, this only served to strengthen the devotion of the two lovers. They decided to elope and bring her father to his senses. Unfortunately, the details of this elopement were overheard by one of her brothers – who was hiding in a nearby thicket – who wanted to prevent what he considered was his sister's disgrace.

The two lovers met on the night elected for elopement, but to their horror her brother rushed from his hiding place and killed him and the two friends by whom he was accompanied.

The bodies were buried in secret in the domestic chapel at Samlesbury Hall and Lady Dorothy was sent abroad to a convent. It is said that she died 'a raving lunatic' and that she can still be seen as a lady in white passing along the corridors and then from the Hall into the grounds.

According to legend three skeletons were discovered near the walls of the Hall, connecting them with the story of the Lady in White.

## THE GHOST OF OSBALDESTON HALL

According to legend, there is a room at the Hall where the walls are smeared with several red marks which can never be obliterated. The story goes that there was once a family gathering at the Hall. After the feast had ended, family differences began to be discussed. This unfortunately led to two of the family challenging each other to a fight to the death. Friends prevented the hot-headiness from going too far, but later the two concerned met by accident and the flames of anger and passion were re-kindled. Thomas Osbaldeston drew his sword and murdered his brother-in-law on the spot. He was deemed a felon and his lands are said to have been confiscated. The murdered man is said to be seen passing from the room with uplifted hands, with blood streaming from his chest.

## THE WARDLEY HALL SKULL

Not far from the centre of Swinton, quite close to the M62 Spaghetti Junction is Wardley Hall. It is here that yet another skull is preserved. According to early accounts the skull belonged to Roger Downes, the last male representative of the family. He is supposed to have killed a poor tailor in London – he was apprehended but had influence and a pardon was forthcoming. However, in a brawl with a watchman on

London Bridge, he attempted to kill the watchman with his rapier. The watchman was quicker than Roger, and decapitated him, his head being catapulted into the Thames. The skull was retrieved and sent to Wardley, where although they tried to remove it from time to time, it always returned.

Another version of the legend was given by the antiquarian Thomas Barritt in which he suggests that the skull belonged to a *'Romanish priest who was executed at Lancaster for seditious practices'*. This story has been thoroughly investigated by various people and it now seems likely that the skull belonged to Ambrose Barlow who was indeed hanged, drawn and quartered at Lancaster in 1641.

The skull was actually stolen in 1930, and gained national publicity. It is now kept in a special niche on the stairway of the Hall, a constant reminder of the violent times of long ago.

There are incidentally, other skulls preserved in the region, including the Affetside skull, Appley Bridge Skull and a skull kept in a cupboard at Browsholme Hall, on the Lancashire – Yorkshire border.

## THE SPECTRE HORSEMAN OF RIVINGTON

There are various accounts of a so-called 'spectre horseman' on the moors around Rivington near Bolton. In one account a group of men taking shelter during a storm, witnessed the ghost on his black horse. One of the men recognised the man as his uncle, who had died some years before. Thinking that the uncle would lead them to safety he followed the apparition. The other men though were wary and stayed behind. One of their number, a servant, told the story of how twelve years before, his own father had returned home in a distressed state. He claimed that he had been approached by *'a small man upon a large black horse'* who asked to be taken to The Two Lads, a pile of stones on the moor. These stones were said to mark the place where two shepherd lads perished in a snow storm. On reaching the spot he was told to throw a stone in the air and on doing so a large black pit opened up in the moor. Apparently at this point, another stranger approached and he was knocked unconscious.

The men hiding from the storm listened in awe to this story and after the storm had passed made their way to The Two Lads stones where they found their friend semi-conscious. It was weeks before the story

unfolded. The man had followed his uncle to The Two Lads and been instructed to wait until midnight. At midnight his uncle, presumably league with the Devil said he would possess the man. They fought and clearly our man won. The spectre horse was said never to have been seen again.

## THE GHOST OF LIZZIE DEAN

A servant girl, Lizzie Dean, is said to haunt the Sun Inn at Chipping near Longridge. There have been reports of doors being slammed, misty figures and noises. It has been suggested that Lizzie Dean is a troubled soul, jilted at the altar, confined forever to where she committed suicide at the Sun Inn.

## MAKING THE RIGHT CONNECTION

Many years ago now, I had reported to me a very strange story indeed. In the industrial town of Radcliffe in Railway Street stood the old telephone exchange. Part of the telephone exchange occupied a much older building, a building that was once known as the Commercial Hotel.

The engineer in charge was called Jack Smethurst and one evening, when he was working there alone, he suddenly noticed a fall in temperature. Looking up he saw a grey, hazy shape rise from the floor until it reached the ceiling. Jack was shaken by the occurrence, but in 1972, two schoolboys also witnessed an occurrence at the exchange. On their way home from school, as boys will, they ventured into the old building for a bit of lark. Suddenly, they were aware of the grey mist or 'ghost mist' as they called it and they ran off terrified.

Rumour has it that a man was once murdered in the old Commercial Hotel and it was he who came back to the world of the living. I preserved a strange piece of glass from that building before it was demolished. On the glass was etched the face of a sailor, complete with a beard. Was it the same man? We shall never know.

## GHOSTS FROM DOWN THE COAL-MINE

Everyone imagines a coal-mine as a noisy, dirty, dark place. Coal-cutting machines tearing down or ploughing the coal on to a conveyor system.

The last place to see a ghost. Yet there were times when the coal-mine was empty because of holidays or strikes, then it became oppressively quiet, dark and mysterious.

In the mines, there is a real danger that men could be left underground after a shift, trapped by a rock fall or simply lost in the workings. A system of checks or tallies was used, a tally being issued on going down, and handed back on reaching the surface.

At the Meadow Pit, Wigan one of the pitmen went down the mine to undertake an inspection one Sunday evening. He went down the shaft and along the underground roadways towards the coal-face. Remember that underground there are no lights, save the light carried by the miner on his helmet or in his safety lamp.

He recalled: *"I saw a light in front of me, a lamp. I kept on going, I said 'I'll come across him', and I went on in. I saw the light further in. Well, I examined all the coal-face and came back. I couldn't see this man and his lamp. Never saw the lamp again. So I came up the pit and asked the winding engine man and he said 'Well there's nobody else down the pit, there's no tally out . . . there must be a ruddy ghost down theer'."*

Collin's Green Colliery near Wigan seems to have had at least two ghosts.

Getting coal from the working coal-face out to the surface was not easy. The coal was loaded into special tubs which were then *'lashed'* or fastened using a special hook on to a chain which hauled the tub of coal up the underground incline. Although men were warned never to ride on these, they did, and many men were killed as a result.

One collier in the 1920s came up to his mate underground as white as a sheet. *"What's up with thee? Thar looks as though thar's seen a ghost."* His friend replied, *"Well you see all them tubs going up, well I keep seeing this fellah riding on the tub and when I get theer, there's nobody on it."*

On another occasion, four men encountered a ghost head on.

Bill takes up the story:

*"I were hanging my lamp up on a prop on a nail when I sees these four lamps coming along all helter-skelter, for all they were worth.*

*'What's up?', I shouted.*

*'We're not gooin' back i' yon,' said a voice.*

*'Why?' I asked.*

*'There's a ghost, a ghost! Yigh there is, there's a ghost theer, it's Smithie's ghost, you know – 'im that were killed theer last week.'*

*'Arr,' I says, 'it's all imagination.'*

*'Nay, it's not', he says, 'this is third time as we have seen it. What are bound to do if thar sees a fog come up like out of the gob?' (The gob is a worked-out underground area)*

*So anyway I persuaded them to go back and it's later on in the shift, all at once same occurs again, these lads belting along this drawing road.*

*'Aye, we've seen the ghost again!'*

*We couldn't get them chaps back. They stopped that place from being worked."*

## THE DUNKENHALGH GHOST

The story goes that a French governess called Lucette, was employed at Dunkenhalgh Hall, near Accrington. One Christmas she became infatuated with a young soldier, as a result she became pregnant. By the time she had discovered her predicament, he had gone back to his regiment. Whether he was killed or did not return we shall never know, but poor Lucette took her own life and that of her unborn child by an old bridge in the grounds.

Sightings of a ghost have been seen in the ballroom at the Dunkenhalgh, and although I have been there many times, the only spirits I have witnessed have been behind the bar.

## THE GHOST OF ROWLEY HALL

Rowley Hall on the outskirts of Burnley once had a visitation from a lady dressed in ball costume of Queen Elizabeth's Reign. Apparently, William Chaffer, a joiner from nearby Worsthorne was making a coffin in one of the barns at night when he received his unexpected guest. Another man claimed he was prevented from going in a particular direction when he went to collect milk from the farm 'by some invisible agency'. Eventually, the ghost of Rowley was laid by *"prayer and supplication at the confluence of two streams."*

## ASTLEY HALL, CHORLEY

Near the centre of the town of Chorley is Astley Hall. Various ghosts have been seen there from time to time including the ghost of an old man entering by the main door and walking upstairs in the company of a young girl. A Victorian maid was seen in the kitchen and an *'Elizabethan'* ghost on the stairs.

## THE GHOSTS OF CHINGLE HALL

Chingle Hall lies near the village of Goosenargh. The rough road leading down to the hall is easily missed and in times gone by it would not have been an easy place to find. The Hall which is privately owned was probably first built around 1260, by a lesser knight Adam de Singleton. Much of the original moat still survives, crossed nowadays not by a drawbridge but by a brick footbridge.

*Chingle Hall*

The Hall was clearly an extremely important place during the period of Catholic persecution in the 16th, 17th and 18th centuries. It probably became a secret Mass centre, and visitors to the Hall are shown a porch window where, it is claimed, a light was shone to show that it was safe

to attend Mass at the Hall. Nicholas Owen regarded as a 'master hide builder' from Worcester, built a series of hides around 1600.

So far, six have been discovered and there are doubtless others. The Hall is associated with the Wall family, John Wall, born in 1620 became an important missionary being a member of the order of St Francis, however in 1679 he was martyred in Worcester. His head however was taken abroad to France where it remained until the French Revolution when it was brought back to England and possibly concealed at Chingle Hall.

There is also a legend that during the Battle of Preston in 1648, Oliver Cromwell came to Chingle and climbed a chimney in order to see the opposition forces.

Today, visitors are shown through the building and are under no illusions that it is haunted. There have been scores of sightings and sounds, ranging from a baby crying, to the creaking of floor boards as an invisible figure passes by. A face has often been seen at a window overlooking the moat, and monks have been seen walking around outside the building. Many visitors claim to feel a cold spot in several parts of the building and during my own visitor, my wife felt 'a terribly oppressive atmosphere' in the chapel. Other people claim to be able to smell incense in the chapel, and if you are brave enough to stay the night, and that can be arranged, there are some things you should know.

The Y-shaped door knocker bangs of it own accord during the night, and on occasions the huge oak door has been found to be unlocked in the morning after being firmly fastened at night.

Other people report that pictures on the walls have rattled of their own accord, doors open and close, there are footsteps and banging, and icy fingers are supposed to have grasped people on the wrist.

## THE LEGENDS & GHOSTS OF RADCLIFFE TOWER

Radcliffe Tower nowadays stands a ruin, sadly neglected amongst the industrial dereliction of the area. Yet, in its time it was an extremely important place being the home of the powerful Radcliffe family. The Tower is said to be haunted by a huge black dog with staring eyes, which wanders around the ruins. The Hall has important associations

with Fair Ellen, and a ballad of how a wicked stepmother killed Ellen and served her up in a pie. It is called:

*THE LADY ISABELLA'S TRAGEDY*

*There was a Lord of worthy fame, and a-hunting he would ride,*
*Attended by a noble train of gentry by his side.*

*And while he did in Chase remain, To see both sport and play,*
*His Lady went as she did feign, Unto the church to pray.*

*This Lord he had a daughter dear, Whose beauty shone so bright,*
*She was beloved both far and near, Of many a Lord and Knight.*

*Fair Isabella (Fair Ellen) was she called, A creature fair was she.*
*She was her father's only joy, As you shall after see.*

*Therefore, her cruel step-mother, Did envy her so much,*
*That day by day she sought her life, Her malice it was such.*

*She bargained with the master cook, To take her life away,*
*And taking of her daughter's book, She thus to her did say.*

*"Go home, sweet daughter, I thee praise,*
*Go hasten presentlie, and tell unto the master cook,*

*These words that I tell thee.*

*And bid him dress to dinner straight, that fair and milk-white doe,*
*That in the park doth shine so bright, There's none so fair to show."*

*The Lady, fearing of no harm, Obeyed her mother's will,*
*And presentlie she hastened home, Her pleasure to fulfil.*
*She straight into the kitchen went, Her message for to tell,*
*And there she spied the master cook, Who did with malice swell.*

*"Nowe, master cook, it must be soe, Do that which I thee tell:*
*You needs must dress the milk-white doe, Which you do know full well."*

*Then straight his cruel bloody hands, He on the Lady lay'd,*

*Who, quivering and shaking, stands,*
*While thus to her he said.*

*"Thou art the doe that I must dress;*
*See here, behold my knife, for it is pointed presentlie*
*To rid thee of your life."*

*O then cried out the scullion boye, As loud as loud might be;*
*"O save her life, good master cook, And make your pyes of me!*

*For pity's sake, do not destroy my ladye with your knife.*
*You know she is her father's joye,*
*For Christ's sake save her life."*

*"I will not save her life," he say'd, "Nor make my pyes of thee,*
*Yet if thou dost this deed bewraye, Thy butcher I shall be."*

*Now when this Lord he did come home, For to sit downe and eat,*
*He called for his daughter deare, To come and carve his meat.*

*"Now sit you down," his Lady said, "O sit you downe, to meat;*
*Into some nunnery she is gone; Your daughter dear forget.*

*Then solemnly he made a vowe, Before the companie,*
*That he would neither eat nor drinke, Until he did her see.*

*O then bespoke the scullion boy, With a loud voice so hye,*
*"Now if you will your daughter see, My Lord cut up that pye.*

*Wherein her flesh is minced small, And parched with the fire,*
*All caused by her step-mother, Who did her death desire.*

*And cursed be, the master cook, O cursed may he be!*
*I proffered him my own heart's blood, From death to set her free."*

*Then all in black this Lord did mourn, And, for his daughter's sake*
*He judged her cruell step-mother, To be burnt at the stake.*

*Likewise he judg'd the master cook, In boiling lead to stand,*
*And made the simple scullion boye,*
*The heir to all his land.*

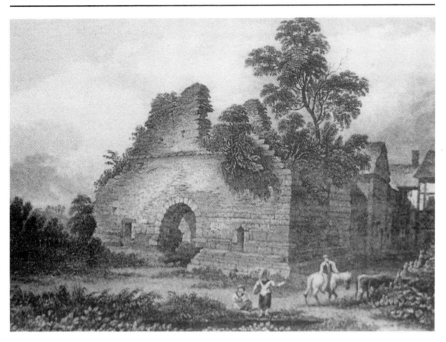

*Radcliffe Tower*

The legend of Fair Ellen and Radcliffe Tower, has not quite died away. A school dinner lady told me that *'Fair Ellen was baked in a pie at the Old Tower and that they say that there are secret passages under Radcliffe. They say that one of the passages goes right across Radcliffe and under the senior school (Radcliffe High) and when we serve up meat pie for school dinners they say Fair Ellen comes, 'cos everything goes wrong that day'.*

One morning the cook arrived early at the school canteen.

*"When I arrived she was waiting at the door and she was terrified to go into the kitchen, she said she could hear a noise of somebody in the kitchen. Just movement – footsteps.*

*Well, we went in together. We unlocked it and put on the lights and went to where the little hatchway was and, as we approached the hatch, it sounded like footsteps of someone walking from one end of the dining room to the other. I was a bit afraid then. We went shakily together and peeped through the hatchway and there was no-one there.*

*When we have meat-pie switches go off, cookers get switched off, boilers, different things like that, a pan fell from underneath a shelf for no reason at all."*

Poor Ellen got the blame.

## SMOKY JOE – THE GHOST OF NEW CHURCH STREET, RADCLIFFE

A long time has elapsed since I recorded a remarkable interview in my home town of Radcliffe with a family troubled by a ghost. The houses have now been demolished, the family moved overseas and I am now happy to relate for the first time, a true ghost story. Introducing – Smoky Joe.

*"It was a man. A friendly kind of ghost. We used to have a sliding door and whenever the little girl was poorly, he seemed to come to guard. The door used to open on its own, no matter how many times you tried to close that door. The catch on it was very hard, but it would open and we used to smell washing or cooking and you also heard the rattle of pots and pans.*

*This particular night I was lay in bed downstairs. I felt more than saw this coldness, a breeze, coming past, and then I saw the shape. He was about six foot, six foot two; no, I couldn't see a face, the shape of him it looked as though he was in a long cape. Always before we heard or saw him, we felt the sensation of a grandfather clock ticking in the corner, but this particular night I saw him. Then I heard zerr-zerr-zerr (very quietly) and then he went as though he was looking out through the window, then it faded."*

The child lay upstairs in bed ill. She also saw the ghost. So as not to alarm the young child, they told her that it was her 'daddy come home from work'.

'The little girl screamed out *"Mummy there's a man at the bottom of the bed"*, so I ran upstairs thinking that somebody had got through the bedroom window, so I charged into the bedroom and there was no-one there. And she said *"Oh he's gone now"*. I said, *"Oh it's only a nightmare love, you was having a bad dream."* I sat with her for about five minutes, till I thought she was calmed down and then I came out of the bedroom again and went downstairs. I'd just got to the foot of the stairs and she screamed out again *"He's come back, he's come back!"* And as I'm going through the bedroom, she says *"He's there, he's just passed you now. Can you see him?"* I looked round

*like that you know, and it just felt as though a coldness had gone right through me, but I didn't see anything, I just felt that. She said, "Is it mi daddy, Is it mi dad?" I said "Yes, love it's your daddy – he's come back from work".'*

Smoky Joe was a friendly ghost, many other things occurred such as the tele-transportation of keys and other objects. Yet the family felt quite safe with Smoky Joe, the Radcliffe ghost.

## THE SALFORD MUSEUM GHOST

A less well-known ghost is the ghost of Lark Hill Place at Salford Museum. Lark Hill Place is a reconstructed Victorian street with shop fronts, a cobbler's shop, pub and blacksmith's shop. Late one evening, one of the security guards was making his rounds. He says: *'I made my way towards the front door and, after I'd tried the front door, I turned my back on the front door to go towards the street. I saw this figure in puffed sleeves; she had puffed sleeves on, up to the shoulders and white gloves on right up her arm and she passed me by the lamp, and I said 'Hello! Can I do anything for you?' She just looked at me and smiled, I saw her face clearly, a beautiful face. She just smiled and nodded and she walked on past the little sweet shop we have on the corner of the street, and I never saw anything again. And on hurrying towards the lamp, this figure disappeared'.*

## TOWNELEY HALL AND THE GHOST OF SIR JOHN

There have been a number of so-called sightings at Towneley Hall and in its extensive grounds. Voices are said to have been heard in the long corridor, and cold chills have been felt in some of the rooms. Perhaps most bizarre was the sound of an army of men marching up the driveway at night.

Towneley Hall is nowadays a museum and art gallery, and the staff assure me, of ghosts there are none. I have also worked at Towneley on many occasions over the past twenty years and in that time I cannot recall anything out of the ordinary, yet the ghost legends persist. Oh, I nearly forgot the one about the White Lady seen near a small bridge in the grounds and the ghost of Sir John Towneley who also is said to make an appearance every seven years, for some reason demanding a life as the price for his unwanted visitation.

## THE TURTON TOWER GHOST

Turton Tower near Bolton is reputed to be haunted by a lady wearing a stiff rustling silk dress who can be heard occasionally passing along the corridors into the rooms. The sound is most distinct on the main staircase which leads from the hall to the upper rooms.

## THE TIMBERBOTTOM SKULLS

Close to Turton Tower there was a farmhouse known as Timberbottom. The house gained considerable notoriety for is association with two skulls, one of which was said to have been 'cut through by a blow from some sharp instrument'. Like many other skulls and relics, they do not like being moved. They were buried a number of times in the churchyard at Bradshaw Chapel, but the disturbances were such they had to be brought back to Timberbottom Farm. The story goes that they were even thrown into a local river, but had to be fished out again because of the disturbances. The remains of the two skulls are now preserved at Turton Tower.

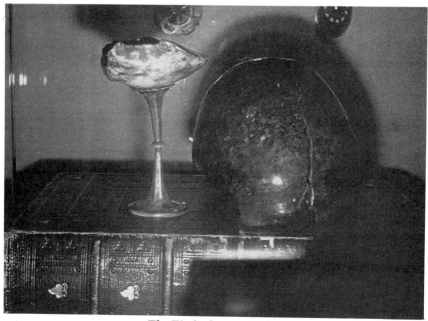

*The Timberbottom skulls*

## THE SPECTRE HORSEMAN OF WYCOLLER HALL

Wycoller is a picturesque community nestled in the shoulder of the moors above the mill town of Colne in north east Lancashire. Today it is technically in a country park and many of its visitors in the summer months view the ruins of the old hall with its giant stone fireplace and nearby stone packhorse bridge.

*Wycoller Hall*

The village was used in the film 'The Railway Children' but has also featured in literature as Fearn dean Manor in Charlotte Brontë's 'Jane Eyre'.

Tradition says that every year a ghostly horseman visits the Hall dressed in costume of 'the early Stuart period'. Whenever he visits, the weather on the evening of his visit is foul. The local residents would hide themselves away in their cottages and wait for the sound of the horseman galloping along the narrow road at full speed. He then crossed the pack-horse bridge and stops at the door of the Hall. (Why should he cross the pack-horse bridge when there is a perfectly good shallow ford within a few yards?) The rider dismounts and makes his way up the broad oak stairs – now gone – into one of the upper chambers. Dreadful screams are then heard, *'as from a woman'* and then groaning. The horseman then gallops away from whence he came.

The Hall was owned by the Cunliffe family and tradition has it that one of the Cunliffes murdered his wife at the Hall.

## PONGAY, THE GHOST DOG OF COPPULL

In 1836 there was a fatal accident near Darkland Bridge at Coppull, when a horse took fright and a young lad was thrown from a vehicle and killed. The event was blamed on Pongay, a ghost said to resemble a dog.

## BLACKPOOL'S GHOSTLY BELLS

Blackpool is perhaps not the place you would first associate with ghosts, yet according to legend, out at sea there once stood a church and cemetery of Kilgrimol. Occasionally, when the time and tide is right, its ghostly dismal chimes can be heard coming from the sea.

# BOGGARTS ABOUT

When is a ghost not a ghost? The answer seems to be – when it is a boggart. The 'English Dialect Dictionary' by Joseph Wright, published in 1898, describes a boggart as *'An apparition, ghost, hobgoblin; an object of terror'*. Yet, although *'a horse can be scared by a boggart'*, these strange creatures were not always unfriendly but could have rather mischievous natures. Such is the case with the boggart of Boggart Hole Clough near Manchester. Although the story exists in other parts of the country, the Manchester version is perhaps best recorded because of its telling in romantic form by Roby in his *'Traditions of Lancashire'*.

A family had long been troubled by the activities of the boggart, and decided in desperation to move away or flit to another home. As the cart draws away the boggart pops up his head to exclaim '*Ay, neighbour were flitting*'.

There were said to be boggarts at Clegg Hall, Rochdale, Clayton Hall at Droylsden and many other places. Some boggarts would amuse themselves by drumming on an old oak chest, or by shaking the hangings of the bed, other boggarts more ill-behaved, are said to have snatched up infants and harmlessly laid them on the hearthstone downstairs.

The Clayton Hall boggart at Droylsden would snatch the clothes from the beds and make the sound of dragging heavy chains through the various rooms. Boggarts could also, apparently, as the whim took them, change their shape and become a rabbit, dog, hare or some other awful, vile, manifestation. It is reputed that the ghost or boggart or whatever, was eventually laid to rest by a local vicar with the words:

*Whilst ivy and holly are green,*
*Clayton Hall Boggart shall no more be seen.*

One description of a boggart says it had '*great lung arms, and a whiskin' tail and hair as black as soot, and rolling een (eyes) as big as saucers*'.

Sykes Lumb Farm, apart from its ghost, also had a boggart. This boggart however would when in good humour, milk the cows, pull the hay, fodder the cattle, harness the horses, load the carts and stack the crops. However it was also known to smash cream jugs, turn horses and cattle loose and, all the while, the wicked boggart would sit grinning on one of the beams in the barn. It even dragged the bed covers off and has been known to grab people's legs as they descend the stairs.

At Hothersall Hall near Ribchester the boggart is supposed to have been laid to rest under the roots of a large laurel tree in the garden because it was such a nuisance to the family.

The boggart of Hackensall Hall appeared as a huge horse, which was very industrious if treated kindly.

## THE CLEGG HALL BOGGART

Clegg Hall lies quite close to Hollingworth Lake near Rochdale. It has been derelict for many years, but still remains an impressive ruin even to this day. Some time about the 13th or 14th century, a wicked uncle destroyed the lawful heirs of Clegg Hall and estates – two orphan children that were left in his care – by throwing them over a balcony into a moat. Clearly the wicked uncle, much in *Babes in the Wood* vein, wanted their inheritance, what happened to him and whether he was successful in his quest is not known. However, ghostly spirits or boggarts began to disturb the peace, even after the house had been substantially rebuilt.

Various attempts were made to lay the ghosts. A pious monk who claimed to be able to lay the ghosts told the local people that the ghosts would only be quietened by the sacrifice of a body and a soul. The pious monk told them to bring the body of a cock and the sole of shoe. Thus ended the laying of the Clegg Hall boggarts.

During a visit in 1972, I was told that footsteps had been heard in the Old Hall. Several local people had seen an apparition of an old man with a pipe in his mouth walking in an old works nearby. Perhaps the boggart still stalks the ruins? Who knows?

## THE BOGGARTS OF WRITTEN STONE FARM

Near the farmyard at Written Stone Farm near Ribchester, lies an enormous stone. The stone is a foot thick, nine feet long and two feet wide. On the side facing the road there is an inscription which reads RAVFFE : RADCLIFFE : LAIDE : THIS : STONE: TO : LYE : FOR : EVER : A.D 1655

Many years ago, the local farmer thought the stone would make a most useful buttery stone and removed it into the farmhouse. However, 'a liberated spirit' would not allow his family any peace at all. Whatever pots, pans, kettles or crockery were laid on the stone, they were inexplicably tipped over and rattled all night along. So troubled was the farmer that eventually he was forced to return the stone to its resting place at the side of the road where it can still be seen to this day. The

stone is on the junction of two farm roads and is easily accessible from the main Longridge to Hurst Green road.

## THE GHOST OF SALFORD VICTORIA THEATRE

Over many years a ghost, The Lady in White, nicknamed Phyllis, was seen by theatre staff and others. Most of the stage crew knew her and often had a laugh at her expense. The strange thing is that she seemed only to appear when things were bad or not going too well.

On one occasion an elderly actress ran out into the street terrified and on another, a barmaid was afraid when the ghost came through one wall and out of the other.

Another former member of staff remarked that *'You could always tell when she was about because you could smell her perfume and on several occasions I have heard her moving about'.*

Next door to the old theatre is the Irwell Castle Hotel. Here a shadowy figure has been seen from time to time and on one occasion there was clattering of pots in the kitchen, although when investigated there was no one there. Could this have been the same lady in white?

The story goes that she fell in love with the leading man in a particular production and was found upstairs by her boyfriend with the actor, perhaps they both rejected her. Whatever happened, distraught, she threw herself from the balcony to her death.

## THE ALDERLEY STREET POLTERGEIST

In the 1960s, the Alderley Street poltergeist in the Hulme district of Manchester made the headlines. Things that go bump in the night became literally true for a family troubled by mysterious knockings. The knocking started around midnight in what one newspaper described enthusiastically as a foxtrot rhythm. The banging or knocking became so bad at one point that the plaster started to crack. Extensive investigations took place, Manchester Corporation officials and the police were unable to find the cause of the mystery knockings.

Recent work into poltergeist activity suggests that one common denominator in such cases is usually a child, often a girl, reaching puberty. In some way it is suggested she is capable, unknowingly and

unwittingly, of producing a physical effect such as knockings or indeed actual movement of objects. With time and maturity the effects cease.

## THE BRADLEY FOLD POLTERGEIST

In 1958, at the jig and tool design room at Mather & Platt's works at Bradley Fold, near Bolton, there was major poltergeist activity. China mugs and vases were inexplicably thrown around the room and smashed. Brass bushes were also projected around the room in which two men worked.

Next it was the turn of the chief inspector at the plant to witness the phenomenon, when a heavy metal pencil sharpener was projected across the room and smashed. On another occasion a bottle of red ink, spilled its contents on a coat and on the arm of one of the workers, before it smashed on to a drawing board. Eventually, the two men moved from the office and the poltergeist activity ceased.

## RING O' BELLS PUB, MIDDLETON

According to legend, a Cavalier was murdered by Cromwell's Round-heads in the area of the nearby parish church and buried in unhallowed ground in the cellar of the Ring o' Bells. The pub has been troubled by a ghost for many years. Lots of people claim to have seen the apparition of a Cavalier dressed in a wide-brimmed plumed hat, cloak, lace collar and carrying a sword. Other people claim to have seen a lady in grey. A glass tankard is said to have regularly been transported across the room and disintegrate without hitting anything. Cold spots are said to occur in the pub and it has been investigated by ghost hunters from all over the country.

In an attempt to prove or disprove the Cavalier story, a grave-digger was employed to find his bones. The grave-digger dug a substantial hole in the cellar but failed to uncover the truth.

## THE MANCHESTER MUMMY

In 1956, workers claimed to have see *'an old lady walking around in a black silk gown'*, a ghost, at the Ferranti works at Hollinwood near Oldham. The works occupies the site of what was once Birchen Bower Farm, and

although there may be no connection at all with the Ferranti ghost, there is a remarkable, if gruesome story attached to the old farm.

In the 18th century, the farm was occupied by a Miss Beswick, who like many people in the 18th and 19th centuries had a fear of being buried alive. Indeed in Victorian times, bells were fitted on the surface which could be rung by the unfortunate subterranean. Miss Beswick died in 1758. So fearful was she of being buried alive, that she had demanded to be kept above ground. Her body was embalmed with tar and wrapped in bandages with only her face exposed.

The mummy was acquired by someone called White who kept it in his home in King Street, Manchester, later placing it in his private museum of curios. It is said that the mummy was kept in the case of an old grandfather clock, her face where the clock face should have been was covered by a veil. On Dr. White's death in 1813, the mummy was transferred to the Museum of the Manchester Natural History Society in Peter Street, where it formed, along with other curiosities including a giraffe and a stuffed horse-head, a fascinating exhibit. The dear old lady was eventually laid to rest in August 1868 in Harpurhey Cemetery, 110 years after her death.

## THE UPHOLLAND POLTERGEIST

In 1904, there was a strange ghostly happening at a cottage in Church Street, Upholland. The cottage was the home of Mrs Winstanley, a widow, with a family of four sons and three daughters. According to the Wigan Observer, *'there were strange noises which seemed to travel across the room in the direction of a walled-in window recess used as a sort of cupboard. Paper was torn from the wall with patches of hard mortar scattered about the room. Stones under the window board, at the bottom of the cupboard were then loosened and flung on to the room floor'.*

Then the interesting statement that, *'it was only in the darkness in the presence of one of the lads, that the agency operated'.* News travelled fast amongst the local people. Large crowds congregated outside the house to observe the phenomena and listen to the window stones which even after being firmly replaced in the light of day, now suddenly, as soon as the lights were dimmed crashed from their housing on to the floor, a sound it was said, that could be plainly heard by the assembled crowd

some 60 yards away. The situation became so bad that eventually the family could no longer sleep in the chamber.

The house was eventually demolished in 1922 when Church Street was widened by the District Council.

## A SINGULAR AFFAIR AT ECCLESTON

In February 1873, there occurred an amazing phenomenon at a house in Eccleston, the whole affair being reported in the Chorley Standard.

*'At Bank House, there reside two elderly ladies and their niece, and they, about a fortnight ago, were very much astonished at being visited at frequent intervals by showers of water descending apparently from the ceiling. At first, no particular notice was taken of the phenomenon, if such it can be called, but the persistency of the downfall became somewhat alarming, the inmates' apparel being often unpleasantly wet, and the expediency of discovering the mystery was manifested. The humid descent occurred sometimes two or three times a day, and lasted probably about two minutes. The effects were observed on the furniture and floor which were covered with water. The cause of this singular visitation has been sought for by workmen, who have examined the flooring upstairs, as well as the ceiling, but nothing that would lead to the discovery of the mysterious shower could, we learn, be discovered. Probably the most singular feature about the affair is that the ceilings were apparently quite dry. The strange phenomenon soon got noised abroad, and many people visited the house and endeavoured to discover the cause, but their ingenuity, so far as we have ascertained, failed to resolve the problem.*

*Various theories were broached, but no definite reason for the occurrence has been assigned. Several persons, we are informed, have experienced the unpleasant shower bath, and have consequently become impressed with the conviction that the extraordinary occurrence has its origin in some occult if not supernatural agency.*

*The inmates of the house have had to don waterproofs to protect them from the showers which have so unaccountably invaded their domestic privacy. We learned yesterday that the phenomenon has not been repeated since the beginning of the present week.'*

# 2

# MYTHS AND LEGENDS

How do you start to tell Lancashire's myths and legends? There are hundreds of stories handed down about secret passages, mysterious occurrences, local heroes, folk memories and the like. The trouble is that the vast majority of these have never been written down. Take for example, the story told to me by my own parents of how Cromwell fired a cannon from a high place called Sailor Brows to Radcliffe Tower, an open distance of over half a mile. Another tale handed down concerns Kersal Cell near Manchester. Time after time I have heard the story of how a secret passage linked Kersal Cell with the cathedral in Manchester. Yet, common sense shows that the construction of a tunnel of such length, almost three miles, would have been impractical and unnecessary.

Whilst on the subject of tunnels, let us start with Manchester's secret tunnels.

## BENEATH THE CITY STREETS

For many years there have been stories and half-truths about tunnels and passageways underneath Manchester. Some years I recorded for the BBC a series of radio programmes which explored something of the truth of these stories and legends.

**Manchester Victoria Tunnels.** Around Manchester Victoria railway station several tunnels were discovered which led from Corporation Street towards the main concourse where the trams leave railway property and venture on to the city streets. Three parallel tunnels were located by British Rail engineers, leading down to the side of the River Irk, which flows beneath Victoria Station at this point. Cut through solid rock the tunnels had been back-filled in Victorian times, it is possible

they linked some small coal-pits which existed near Ancoats with the river, but this is purely guess-work in the absence of hard facts.

**Victoria Street Tunnels.** There are several stories of an underground street complete with shop-fronts existing beneath the road in front of Manchester Cathedral. The road in front of the Cathedral is on arches – a viaduct – and the only remains that exist below ground are of Second World War air-raid shelters and an amazing tramway pole which penetrated through the top of the arch to ground level. Rumour has it that considerable excavation took places for fortification purposes during the Civil War, but no evidence of this has been found. A tunnel was said to lead from St Mary's Gate up Deansgate where it connected with many of the old shops, it was said to be able to accommodate a horse and cart. No evidence for such a tunnel was discovered.

Another tunnel was supposed to start near the cathedral (there is an account of someone entering the tunnel near the Cathedral) under Market Street, towards Smithfield Market. From there, it is said to continue beneath Store Street, Jutland Street to Downing Street, where it was uncovered in the 1930s but not explored. Legend has it that the tunnel was constructed to convey cattle avoiding the narrow city streets, and was completed in about fourteen months.

During the construction of the Arndale Centre a shaft was uncovered in what used to be the *Wishing Well* Restaurant which could have been an air-shaft for the tunnel.

**Manchester, Salford Junction Canal Tunnel.** A tunnel runs from Granada Television under the city streets to beyond Deansgate. It was a canal tunnel constructed in the 1830s from the River Irwell to the Rochdale Canal, to avoid paying tolls on the Bridgewater Canal connection. The tunnel which is bigger than the Underground still has water in it along part of its length. During the Second World War, it was used as an air-raid shelter and there are still some fitments preserved below ground. Originally the canal came back into daylight via two twin-locks at a site now occupied by G-Mex. There was also an enormous underground dock with a link into the Great Northern Goods warehouse on Deansgate.

**The Ardwick Tunnels.** Near Ardwick Green is a complex of underground passages and caverns cut in the soft red sandstone of the area. Some passages are very small and coffin-shaped, others enormous – one

I visited could hold six double-deck buses. There are few clues to the origins of these tunnels, which are now quite dry. Suggestions have ranged from military tunnelling exercises, extraction for lime, through to water supply for the nearby canals. The truth seems to have been that they were used in the main for storing drinking water, the water table now having fallen. However, that does not explain why these tunnels are irregular in shape and size, looking in plan as if spaghetti had been dropped on a plate.

**Bank Top Tunnel.** A tunnel once existed, built by the Duke of Bridgewater, to allow his boats loaded with coal access to a point near Piccadilly Station. The tunnel started somewhere on the river Medlock which was then navigable for small boats.

## WHERE THE DOORSTEPS ARE MADE OF TREACLE ...

There are a number of places in Lancashire where traditions of silliness have grown up. Ken Dodd started his jam-butty mines in Knotty Ash, but in Sabden beware, because there are Treacle Mines. At one time there was considerable correspondence in the local paper about the success of local treacle mining. This none-too-serious correspondence asked questions about the thickness of the vein and the difficulties of mining and extracting wet treacle. At one stage it was even proposed that a pipeline be installed to pump liquid treacle straight to the docks in Salford. All this coupled with tales of take-over by the Great Harwood Snuff Quarries make fascinating reading.

At New York Farm in Sabden, scrawled on the side of a metal tank is crude sign pointing up Pendle *'To the treacle mines'*, believe it at your peril. When the oil-men came with their sophisticated survey equipment some years ago, they were asked tongue in cheek more than once how much treacle they had found.

Bill Dewhurst and his family established a toy company several years ago to make treacle mine characters and there is now an exhibition of *'Treacle Mining'* behind the *Pendle Witch* public house in the village.

## THE DEVIL'S FOOTPRINTS ON PENDLE

On the lower slopes of Pendle Hill above Churnclough reservoir is the site of what was once an enormous landslip. The landslip which

probably occurred at the end of the Ice Age left enormous boulders strewn over a large area and exposed a rock-face nowadays known as Deerstones. It is amongst these rocks below the cliff that the Devil's Footprints can be seen.

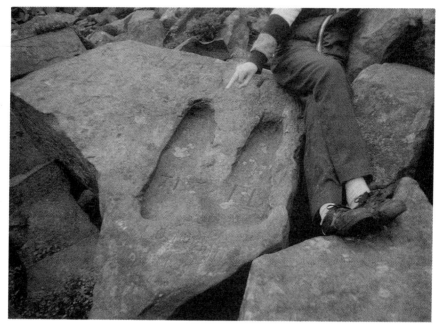

*"The Devil's Footprints"*

The Footprints are very large and doubtless their size has been increased by visitors over the years. The Devil, apparently upset at the building of Clitheroe Castle on his domain jumped from Hameldon Hill across to Pendle his footprints leaving an impression on the rocks as he landed. He filled his apron with rocks from Deerstones but, as he took off, his apron-strings broke and he dropped the rocks in an area known as Apronfullhill. He went to seek his revenge on Clitheroe Castle, knocking a hole in the wall.

According to one writer, ' . . . *when he alighted upon the stone, he must have crossed his legs, for the left footprint is on the right side of the stone. The outline of the foot is quite perfect, but the other is ill-formed. This is accounted for, by the well-known fact, that the Devil has a club-foot'.*

The story is told in various forms by locals, but the reality is that the boulder is of local millstone grit and was originally a natural feature in common with many odd shapes that survive on boulders.

## THE LEGEND OF KERSAL HALL – or, The Salford Fairies

Kersal Hall before its demolition stood on the north side of Littleton Road, Kersal, and should not be confused with Kersal Cell, its near neighbour.

According to legend, Richard Peveril defended the Hall against Norman intruders but was slain – his body being thrown in the River Irwell – which runs close by. The Saxon Knight responsible for Richard Peveril's death took immediate possession of the Hall, but his victory was not to be as sweet as he might have expected. Retribution for Richard Peveril's untimely death came from a most unexpected source when *'the gnomes of the lower earth and the spirits of the upper air'* intervened.

The following morning, the Knight's body was found on the threshold of the Hall with a notice written in his own blood across his temple warning that other would-be trespassers would be prosecuted according to fairy law.

## THE CHEEK OF THE DEVIL

On another occasion, Eustace Dauntesey, as occupant of Kersal Hall, had wooed an attractive young woman, only to find that her interests lay elsewhere. He drew a magic circle and summoned the Devil for his help. A deal was struck in which his own soul would be taken by the Devil when the Lady died. The Lady would be won over to Eustace's affections and the Devil would always be at his side as a companion.

Eventually the young Lady succumbed to Eustace's charms and they were married. They turned to leave their place of marriage only to find that the elements were unfavourable, the flowers strewn before their feet sticking to their wet shoes.

Eventually they arrived at the Hall. Suddenly Eustace's bride began to melt away before his eyes rising *'slowly to a fleecy cloud'*. Just then, Eustace felt someone touch him. The bargain had to be completed. Before him opened a yawning gulf and he felt himself gradually being drawn down.

## THE GOBLIN BUILDERS OF ROCHDALE

A Saxon thane called Gamel, decided to build a church on the banks of the River Roch. A place was chosen ' . . . *on the north side of the river, in a low and sheltered spot now called the Newgate'*. Stakes were driven into the ground, timber was gathered and huge piles of stones delivered to site. Several courses of stone were laid ready for the grouting or cement.

During the course of one night, the whole lot was conveyed *'without the loss of a single stone'* to the top of a hill on the opposite bank. Gamel was outraged at what he saw as a trick and ordered everything back down the hill again. But, once more, they were moved back up the hill. Gamel then took the hint and allowed the church to be built on high ground above the river.

Curiously however, there are several such stories in Lancashire. During the construction of St Peter's church in Burnley it was said that ' . . . *whatever work was done by the workmen during the day was removed to the present site . . . by supernatural agents in the form of demon pigs'*.

Colne church is said to have suffered a similar fate during its construction: ' . . . *every stone put on by day at Church Clough disappeared during the night and carried by unseen hands to the present site and there skilfully laid together'*.

It seems highly likely the stories are remnants of Scandinavian stories and legends as variations of the so-called goblin builders occur in Icelandic, and Norwegian traditions.

## JEPPE KNAVE GRAVE, WISWELL

High on the moor above Wiswell are the remains of Jeppe Knave's grave. Various accounts suggest that Jeppe was beheaded as a thief, possibly in the 11th century. An examination of the site today however suggests a much earlier origin as a tumulus or burial mound.

## MURDER AT THE DEERPLAY INN

At over 1300 feet above sea level, the Deerplay Inn on a dark winter's night with the mist swirling could well have been the scene for some dark deed. Local folk, when pressed, will tell you the legend of Briggs and Dickinson.

The story goes that: '. . . *they (Briggs & Dickinson) called in late after closing time. Well, with being an inn, they were supposed to be open for 24 hours a day and the landlord said he weren't going to bother with them as he'd shut up, and of course an argument started . . . they'd broken a window and they threw a half crown on to the table to pay for the window and when the landlord went to pick the half crown up they hit him with a stick and then the landlord's son came down(stairs) and a fight started. And they shot the landlord's son. They went down the road and my great grandfather was coming up the road . . . and they said they were two constables and they were going to arrest him, for murder. Another fight started and they robbed him. When they were Tried, they said they hadn't been in this district. My great grandfather went to Lancaster to identify his pocket knife. And that helped to hang them. He'd had a lot of gold sovereigns in his pocket but they never found those!'*

## THE HOLY HAND OF EDMUND ARROWSMITH

In a church at St Oswald's Church at Ashton-in-Makerfield near Wigan, is preserved the withered hand of St Edmund Arrowsmith. In the past it

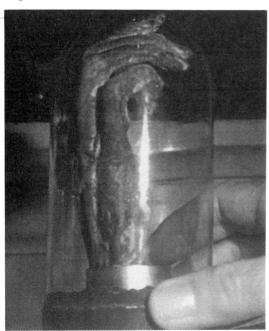

was said to possess powers of healing and was much sought after by the sick.

Edmund Arrowsmith was a Catholic priest executed at Lancaster in 1628. As he was about to meet his maker, he asked his attendant to cut off his right hand so that it might perpetuate his work. There are various stories handed down as to why he was being executed. One says that he was hanged for rape. It is possible that various miraculous

*The sacred hand of St Edmund Arrowsmith.*

stories were created simply to avoid embarrassment to the church over a charge of rape.

He was hanged, drawn and quartered, which involved his hands being cut off. Someone collected the right hand and took it to Bryn Hall near Wigan.

The hand was moved to various locations within Lancashire and there is a publication issued by the Catholic church in 1737 attesting to the healing powers of the hand. A twelve-year-old boy from Appleton-in-Widnes, had been ill for some fifteen months. His condition had worsened, he was losing the use of his limbs, he had loss of memory and his eyesight was impaired. The rear of the Holy hand was applied to the boy's back, stroked down each side of the spine, making a cross, the whole procedure being accompanied by an appropriate prayer. The procedure was done twice, then miraculously, the boy got up out his chair and walked about the house. He was cured.

People came from far and wide to touch the Holy hand; they arrived on crutches and left walking.

A more poignant story has survived about the Holy hand. The witness stated: *'I saw a poor maniac being dragged along by two or three of her relatives, and howling most piteously. I asked what were they going to do with her, one of them (presumably her mother) replied: "And sure enough, master, we're taking her to the priest, to be rubbed by the holy hand, that the devil may leave her." A short time afterwards I saw them returning, but the rubbing had not been effectual. A policeman assisted to remove the struggling maniac to a neighbouring house, till a conveyance could be got to take her to Newton Bridge railway station'.*

## THE LEGEND OF THE DEAD HAND AT INCE HALL

One of the early occupiers of Ince Hall lay on his deathbed. A lawyer was called for in order to make his will, but before he could reach the Hall, the man was dead. The body of the dead man was rubbed with the holy hand of Edmund Arrowsmith and it was stated that the hand revived sufficiently to sign the will. After the funeral, an unsigned will was produced by the daughter of the deceased, leaving the property to his son and daughter. But the lawyer produced the signed will, which left all the property to himself.

As one might expect there was a quarrel with the lawyer. The son thinking he had mortally wounded the lawyer left the country never to be seen again. The daughter also disappeared and it was not for many years that the truth was revealed when a gardener turned up a skull in the garden of the Hall. It is said that the murdered daughter's ghost hung suspended before the lawyer wherever he went, ending his days in *'remorse and despair'*.

## THE STORY OF THE REPENTANT KNIGHT

On the banks of the River Irwell near Salford lies Kersal Cell. Looking at the area today, it is hard to imagine it as being remote and beautiful. Yet that is exactly how it was when Sir Hugh le Biron, a knight, left his home at Clayton Hall for the Holy Land. He was particularly successful at head cleaving, so successful that after a while his conscience began to trouble him. Eventually, he returned to Lancashire and as he entered the avenue to his home, he met a funeral procession bearing the remains of his Lady. This was a deadly blow to Sir Hugh, who presumably interpreted events as being some kind of retribution for his deeds in the Holy Land. He renounced the world and retreated to the solitude of Kersal Cell, only occasionally venturing out to explore the *'picturesque heights of Kersal'* and *'the wooded ways of Prestwich'*.

## THE GORY DITCH

According to various accounts there was once a ditch called Nicko or Micko constructed in a night by men defending themselves from the invading Danes. The ditch stretched from Ashton Moss to Ouse (Hough's) Moss near Gorton. The local tradition says that a *'great battle'* was fought along the line of the ditch which is said to have been filled with human gore. The early sources suggest the very name Gorton came from this, but it is much more likely that it came from gore meaning mud, or dirt. Another conjecture is that the name of the ditch – Nicko or Micko – might have come from the Anglo-Saxon *micel, mucel* meaning a great ditch.

## BARCROFT HALL AND THE IDIOT'S CURSE

Not far from Towneley Hall at Burnley is Barcroft Hall. According to tradition one of heirs to Barcroft, William, was 'either an idiot or

imbecile'. His younger brother Thomas, clearly not through any bond of brotherly love, fastened him up with a chain in one of the cellars. This charming gentlemen then claimed the property as an inheritance, knowing full well that his own brother was starving to death in the cellar. William, before he died in 1641, 'in a more lucid moment' cursed the Barcroft family with words to the effect that the Barcroft family name would disappear for ever, which eventually it did, as the line died out.

## THE LEGEND OF JENNY GREENTEETH

As a small child, I can well recall seeing thick green weed covering the surface of our local canal. My mother, cautious like every mother, used to warn me in no uncertain terms to *'keep away from the water, Jimmy Greenteeth will drag you in and drown you'*. And of course I believed her. Jenny or Jimmy Greentooth or Greenteeth is a malevolent water spirit said to be frightful and grotesque, just waiting for a lonely victim to fall into the trap.

# RAISING THE DEVIL

## CLITHEROE GRAMMAR SCHOOL

There are two curious stories in Lancashire about the raising of the Devil by grammar school boys. The first of these stories is recorded in an obscure 19th century publication as follows:

*"According to a story related to the writer by an old lady, the scholars at Clitheroe Grammar School once raised the Devil. It was many years ago when the school stood in the churchyard and Reverend Mr Wilson was its headmaster. Mr Wilson, who then lived not far from the school, on the opposite side of the road, was one day taking a nap after his mid-day meal, when he was awakened by the sudden rising of a tremendous storm. The wind howled, the lightning flashed, the thunder rolled, and the rain came down in sheets . . . he hurried across the school and found that the lads had raised the Devil, in the orthodox way, by saying the Lord's Prayer backwards. There was his Satanic Majesty seated in the middle of the school, the boys standing round trembling with fear, and do what they would, they could not get rid of their terrible visitor. They repeated the Lord's prayer forwards, said the Apostle's Creed and read various passages of Scriptures, but all to no purpose. They then set him*

*various tasks to perform, but he did them all. At last, a happy thought struck Mr Wilson, who told him to knit knots out of a strike of sand. This feat was beyond even his power, so that he had to retire baffled. The narrator of this story said that the Devil came up through the hearthstone, which ever afterwards showed the cracks he had made in coming through. She said she had seen them, and that thought the stone was several times replaced by a new one, it was of no avail, for the cracks always reappeared in the same place as the old one".*

Mr Wilson was indeed headmaster of Clitheroe Grammar School and was its longest serving headmaster. The school existed in the church grounds 1775-1813, and was eventually re-built at its current location at York Street.

## BURNLEY GRAMMAR SCHOOL

At Burnley Grammar School exactly the same thing was done, again, by saying the Lord's Prayer backwards. Th'owd lad started to make his appearance through the stone flag floor of the school-house. At this point the boys panicked and began to hammer him back into the ground with hammers and tongs. Eventually they drove him back from whence he came, leaving a black mark on the flagstone as proof. This mark was said to have existed for many years before the floor was eventually boarded over.

## THE WITCH OF BERNSHAW TOWER

Bernshaw Tower once stood in Cliviger Gorge on the Yorkshire side of the border. The area is still remote and mysterious to this day, but in times gone by it must have seemed a forbidding place. The last owner of Bernshaw Tower is described as being one Lady Sybil, of particular intellect, *'beauty'* and wealth. Being of a somewhat curious nature, she often climbed the nearby Eagle's Crag to view the countryside. Whilst she was on the Crag, for reasons not at all clear, she was induced to sell her soul to the Devil, bonding her troth in blood. All was not lost however, for she had an admirer, Lord William of Hapton Tower, who constantly asked for her hand in marriage, but was always rejected by Lady Sybil. Presumably in desperation, for they were superstitious folk, he turned to Mother Helston – *'a Lancashire witch'* – who, after various spells and incantations, promised him success on the next All Hallows Eve.

Placing great trust in Mother Helston, on the appointed day, he went a-hunting and on nearing the Eagle's Crag in Cliviger he startled a milk-white doe, his dogs giving chase. They searched the countryside all around without success, then as is the way of old legends, quite unannounced, a strange hound joined them. Lord William recognised the hound as a familiar or helper of the witch Mother Helston, sent to help him on his quest.

On passing the Crag, the milk-white doe suddenly dashed out, causing Lord William's horse to all but throw him into a nearby clough.

The hound then rushed forward, seizing the doe by the throat. Lord William, by this time entering into the spirit of the thing, slipped an enchanted silk leash around her neck and led her away to Hapton Tower.

Such is witchcraft, that Mother Helston arranged for an earthquake to occur during the night, and in the morning the milk-white doe was wondrously replaced by the *'fair heiress of Bernshaw'*.

Various counter spells were employed and, eventually, Lord William and Lady Sybil were wed. However, it was a wedding not made in heaven but rather the other way, for within a year she was back to her old tricks, this time changing herself into a beautiful white cat. However, in the best sadistic traditions of old legends, Robin – a man-servant – cut off her paw in a most cruel way.

Lady Sybil was, naturally enough, found exhausted in bed when Robin arrived with a gruesome hand complete with *'costly signet ring'*. All was revealed!

More magic was to come however, the hand being re-attached to the dear Lady's arm, the only evidence being a red scar around the wrist.

All this devilry and surgery was too much for Lady Sybil. Before she died, the local clergy helped her to break her pact with the Devil. Lady Sybil, having made up with her husband, died in peace.

A curious legend which is probably related to the story of Lady Sybil, is that of a ghostly huntsman who rides on horseback hunting a milk-white doe on All Hallows Eve at Eagle's Crag. Eagle's Crag is also known locally as the Witches Grave, presumably because it is supposed that it was Lady Sybil's final resting place.

## THE LEGEND OF THE EAGLE AND CHILD

'The Eagle and Child' is a popular pub name, with a Lancashire origin. It is also the crest of the Stanleys, the Earls of Derby. Sir Thomas Lathom had one child, a daughter. He had what today would be called an affair with 'a young gentlewoman' who bore him a son. Sir Thomas desperately wanted a son to inherit his name and fortune and he contrived an ingenious plan to ensure the illegitimate child became his heir. The infant was to be placed by a *'confidential servant'* at the foot of a tree in his Park, a tree frequented by an eagle. The idea was that the Lord and Lady taking their usual walk would find the child by accident, the old Lady would consider it a gift from heaven and adopt the boy as heir.

The plan worked and the child was given the odd-sounding name Oskatel, Mary Oskatel being the name of the mother. They were so over-joyed with the child, that from that time on, the crest of the Eagle and Child was used.

On his death bed however, Sir Thomas had pangs of conscience and bequeathed the principal part of his fortune to his daughter Isabel. This left Oskatel, who by this time was a Knight, some minor estates.

The legend of the Eagle and Child is very old; one account gives the credit to King Alfred discovering the child and naming him Nestingum.

## THE FAIRIES OF MELLOR, BLACKBURN

Yes, it was firmly believed there were fairies in Blackburn. A man was enjoying a summer evening on Mellor Moor, near to the Roman encampment, when suddenly his attention was drawn to the appearance of a dwarf-like man in full hunting attire: boots, spurs, a green jacket, red hairy cap, and a thick hunting whip in his hand. He ran across the moor for some distance before he was out of sight. The popular local opinion is that there is an underground city at Mellor Moor and that an earthquake swallowed up the Roman encampment. At certain times of the year, the hill folk may be heard ringing their bells and indulging in various festivals.

One very well-told story about fairies in Lancashire concerns two men out hunting rabbits. They placed their sacks over the entrances of what they supposed were rabbit holes, but were in fact, the homes of fairies.

The fairies rushed into the sacks and the two men set off home with their catch. Imagine their surprise when one of the fairies called out: *"Dick where arti?"*, to which Dick replied, in characteristic fairy talk, *"In a sack, On a back, Riding up Barley Brow"*. The two men dropped the sacks and ran, it is said they never went poaching again.

Fairies, it would seem were a breed apart from hobgoblins and boggarts. They were far more friendly and helpful – but could be quite cruel too.

## THE BROWNIES OF BROWNSIDE

Brownside, near the village of Worsthorne is recorded as being frequented by brownies. Their favourite place was said to be the ford across the river Brun. The story goes that: *'A woman who lived at Bottin, when in a communicative mood, used to tell how, on the occasion of fetching a doctor to her father from Burnley after midnight, she saw a brownie sitting behind a hedge and taking it quite coolly. It was in size equal to a man, but devoid of clothing'.*

## THE FAIRIES OF ROWLEY

*'At the bottom of the great meadow at Rowley there was a sheltered and sunny spot between the wood and the river Brun that was held to be the happy hunting ground of the fairies. Shreds and patches of their dresses, but of the tiniest kind, were said to have been found. Even fairy smoking pipes were said to have been seen strewn upon the ground'.*

## AN EYE FOR AN EYE

One story concerning fairies is of a poor woman filling her water jug at a well near Staining on the Fylde. She wanted water to bathe the eyes of her child. Suddenly a handsome young man spoke to her and presented her with a box of ointment for the child. Obviously, as any mother would be, she was grateful, if not a little mistrustful. So she tried a little of the ointment in one of her own eyes before trying it on the child.

Some time later, she was in Preston and to her amazement she saw the handsome young man stealing corn from the mouths of sacks that were for sale. She accosted him and he asked how it was that she could see him. She explained how she had used the ointment in her own eye. The young man, immediately struck her eye out leaving her blinded.

## A PLOUGHMAN'S REWARD

Not all fairies were as vindictive as the one from Preston. A ploughman working in the fields one day, heard someone say behind him, *"I've broken my speet* (spade)." On turning round he saw a lady holding in her hand a broken spade, a hammer and some nails. She begged for him to help repair it. This he did, instantly receiving a handsome reward from the lady, but then she vanished as quickly as she came, sinking into the earth.

## A MIRACULOUS FOOTPRINT IN BRINDLE CHURCH

Beneath the eastern gable of the chancel lies a huge stone coffin with a cavity for the head. In the wall just above it is a small indentation resembling the form of a foot. According to tradition, this is the high-heel shoe-print of a Catholic theologian who, in a heated debate, declared that his foot should sink into the stone beneath his feet if his doctrine was untrue; *'upon which the reforming stone instantly softened and buried the papistical foot'*.

## THE DULE ON THE DUN

There is a story that a tailor, probably from one of the villages near Clitheroe in the Ribble Valley, who sold himself to the Devil. He signed a contract in blood, pledging to give up his soul to the Devil after seven years. In return the Devil would grant three wishes. The poor tailor asked for a collop of bacon, that his wife were *'far enough'* and that she were back home again.

Seven years passed by and the Devil arrived to claim the tailor's soul. Seven years is a long time to consider and the tailor trembling at the sight of the Devil, suggested somewhat timorously that the Devil hadn't really fulfilled his part of the bargain to any great extent. The Devil was goaded into granting the tailor another wish.

Quick as a flash the tailor said *"I wish thou wert riding back again to thy quarters, on yonder dun horse and never able to plague me again or any other poor wretch whom thou hast gotten into thy clutches."*

The Devil with a roar, departed at great speed 'riveted' to the back of the dun horse much to the delight and joy of the tailor.

## PEG O' NELL'S WELL, CLITHEROE

Peg o' Nell's Well stands on the Yorkshire side of the River Ribble at Clitheroe in Lancashire. Although, originally in Yorkshire, I have included it as it is very much part of Clitheroe's historical past. Waddow Hall overlooks the Ribble near Brungerley Bridge and Peg o' Nell's Well is close by in a meadow on the edge of the river.

Peggy is supposed to be an evil spirit present in the well, terrorising *'domestics at the Hall'* with her misshapen figure. A stone figure, which is still there, was placed by the well, it is said to partly alleviate the fears of the domestic staff at the Hall. However it is much more likely it was a Roman Catholic statuette and the well was probably revered much like St Ellen's Well at Brindle. Later the statue was broken, the head being stored for a long time in one of the attic rooms at the Hall.

*Peg o' Nell's Well*

In times gone by, everything that went wrong at the Hall was blamed on Peggy, the spirit of the well. If the wind moaned then *'it was Peggy at her work'*, and if she was not appeased, she would reek her revenge. The story goes that on one occasion master Starkie, returned home very late, full of ale and with a broken leg, the result of a hunting accident. Peggy of course was blamed.

A short time afterwards a *'Puritan preacher'* was overwhelmed by the force of the Ribble whilst attempting to cross the Hipping Stones, or stepping stones at Brungerley. The stones incidentally, have recently been exposed after many years and are also famous for their association with King Henry VI who is said to have been captured thereabouts.

Back to our story: Mrs Starkie was greatly concerned at his late arrival. She had sent for him to exorcise her 10-year-old son who was *'grievously afflicted with a demon within'*, or – as was suspected – by Peg's influence. Eventually two trusty men-servants found the preacher wet and dripping and brought him up to the Hall.

On hearing the preacher's story of being suddenly overwhelmed by the *'a sudden flush'* of the river, she immediately blamed Peg. She was so outraged by what had happened that she rushed from the Hall down to the riverside where *'Peg stood quiet enough near a spring'* and with one blow of an axe, severed Peg's head from her body.

It is not clear from the narrative if the decapitation was to the statuette or a manifestation. Sounds and disturbances continued for many years and it was not until quite recently following an exorcism at the Hall, that the disturbances ceased. Waddow Hall is incidentally private and the headquarters of the Girl Guide Association.

## HOGHTON TOWER AND SIR LOIN

Hoghton Tower is without doubt one of the most exciting buildings in Lancashire, built on a prominence on one of the few cliffs of any height in the county. Hoghton Tower, was built largely in the 16th and 17th centuries. The great hall has to be seen to be believed, it is without doubt superb.

In 1617, James I visited Hoghton Tower with his retinue. The King's visit was feared in those days; his extravagance knew little bounds, and often left the host deprived, paying off the debt for generations to come. The

story goes that King James, amidst his gluttony and merriment, knighted a loin of beef and ever since it has been called Sirloin. One reference suggests that it was all Dr Johnson's fault that under *SIR* in his famous dictionary it says *'A title given to the loin of beef which one of our Kings knighted in a fit of good humour'*.

A modern dictionary offers another explanation suggesting the origin is more to do with a Middle French name for sirloin, namely *surlonge*.

## MABS CROSS, WIGAN

Little now remains of the old cross which was witness to the legend about Lady Mabel Bradshaigh. Her husband, Sir William Bradshaigh, was reputed to be a great traveller, soldier and – in another report – a felon. On one occasion he was away from home for over 10 years, and not unreasonably Lady Mabel assumed him dead, and married a Welsh knight. Sir William however was far from being dead and when he returned, for reasons that are unclear he dressed as a palmer and mixed amongst the poor of Hage (Haigh). Lady Mabel observed how much this palmer resembled her first husband, but the knight, her second husband, chastised her for her stupidity.

On hearing this, Sir William, clearly not a man to take such matters lightly, gave chase to the Welsh knight, overtook him near Newton Park and slew him.

One could pass comment on the morality of murdering someone to preserve one's marriage, but Lady Mabel's ordeal had not yet finished. She was forced by *'her confessor'* to do penance by walking barefoot and bare-legged once a week to a cross near Wigan, a distance of about two miles.

Even in those barbaric times, Sir William's conduct could not be condoned and he was outlawed for a year and day for killing the Welsh knight. The legend goes on to say, with little credulity, that Sir William and Lady Mabel lived happily ever after.

# THE LEGEND OF THE EVER-BURNING WELL OF LANCASHIRE

In Camden's Britannia of 1695, he reports that *'within a mile & a half of Wiggin is a Well; which does not appear to be a spring but rather rain water. At first sight, there's nothing about it that seems extraordinary; but upon emptying it, there presently breaks out a sulphureous vapour, which makes the water bubble up as if it boyl'd. A Candle being put to it, it presently takes fire & burns like brandy. The flame, in a calm season, will continue sometimes a whole day; by the heat whereof they can boyl eggs, meat etc., tho' the water itself be cold. By this bubbling, the water does not increase; but is only kept in motion by the constant Halitus of the vapours breaking out. The same water taken out of the Well will not burn; as neither the mud upon which the Halitus has beat'.*

That well wherever it was, is no more, and at first, the very notion of a perpetual fire does seem absurd. Yet, consider the facts: the Lancashire coalfield is extensive and coal over time decomposes with the emission of methane gas which will burn or, in the correct proportions of gas and air, explode, as many colliers have found to their cost. In 1975, Keith Hayes a farmer at Daisyhill near Westhoughton had such a fire on his land. Mechanical excavators broke through a cap rock and the methane was released in such quantities that it bubbled up in a stream and on the nearby banking. It burned for some time before the gas was piped away, but it does confirm that without doubt, 'wondrous burning wells' are not just a figment of 17th century imagination.

# THE LEGEND OF THE GIANT COW

Near the town of Longridge, on Halfpenny Lane, is a house, once a farmhouse, called Old Rib. At first it might be thought that there was an association with the name Ribchester, but that is not the case. A huge rib, a yard long still hangs over the doorway of the house. Legend has it that the rib belonged to a cow of truly gigantean proportions that wandered on the fells of Parlick, Bleasdale, Bowland and Browsholme. The cow was reputed to be able to fill any pail with milk. Times were hard and food sparse, and people were said to have journeyed from miles around to try their luck at filling their pail.

## THE SMITHILLS HALL FOOTPRINT

George Marsh was born about 1575. He was educated at Bolton Grammar School and, following the untimely death of his wife, he attended Cambridge University, eventually becoming curate of All-Hallows in London. He was without doubt an ardent Protestant and on one of his trips north in 1555, he was arrested and 'voluntarily examined' by a Mr Barton of Smithills Hall. The story goes that, taunted by his examiners, he stamped his foot on to the flagstone floor and prayed that there might be a sign for all to see. The stone is a geological peculiarity rather than the impression of man's foot, yet the legend lingers on. As for Marsh, he remained true to his faith until the very end when he was burned at the stake at Chester.

At the beginning of the 18th century, the stone was removed and dumped in a nearby clough with the result that alarming noises were heard at the Hall. These did not cease until the flagstone was reinstated to its proper place.

In 1732, a ghost of a minister was seen, carrying a book in his hands. Whether this is the ghost of Marsh is not known, but there have been many disturbances at the Hall over the years including a phantom cat which scratched the faces of people whilst they slept.

## THE CHYLDE OF HALE

John Middleton was born in the village of Hale near Liverpool where he became something of a local legend. His gravestone bears the simple inscription *'Here lyeth the body of John Middleton, the Chylde of Hale, born 1578 Dyed AD 1623'*, saying nothing about the fact that he was said to have been 9 feet, 3 inches in height; the breadth of his palm being eight and half inches.

He was very much a novelty figure. Sir Gilbert Ireland took him down to the Court of James I, where he wrestled with the King's wrestler whom he overcame, accidentally dislocating the wrestler's thumb.

Several portraits of him were painted and he rapidly became a celebrity. One of the more fantastic claims for John Middleton was that whilst he was asleep in the sands near Hale, on awakening he discovered he had grown so much that all his clothes had burst.

Another tall tale is that on his way home he was attacked by a huge bull which he promptly threw a great distance!

## DILDRUM – KING OF CATS

This tradition was often heard in south Lancashire. A gentleman one evening was sitting cosily in his parlour, when he was suddenly interrupted by the appearance of a cat which descended the chimney calling out *"Tell Dildrum, Doldrum's dead!"* He was naturally startled at this sudden appearance of a talking cat and later when his wife entered the room he told her what he had seen and heard.

Her own cat which had entered the room with her suddenly exclaimed *"Is Doldrum dead?"*, and immediately rushed up the chimney and was heard of no more.

This time we cannot lay the blame at the pen of Andrew Lloyd Webber. There were many conjectures about these strange events, the consensus being that Doldrum had been king of Cat-land and that Dildrum was the next in line to the title.

## SAMBO'S GRAVE AND THE COTTON TREE AT SUNDERLAND POINT

Sunderland Point lies across roughly a mile from the village of Overton, near Morecambe. It is small close-knit community, which still has fishing tradition. The community is reached by road from Overton, but only when the tide is right, for the road is often covered at high-tide, cutting off Sunderland Point to road traffic.

Once, before nearby Glasson and the port of Lancaster were developed, it was an important port for the import of cotton and other goods. There are still remnants of that age, the jetty and customs house, but more famous is the so-called Cotton tree which grows on the side of the quay. How the seed of such a tree took hold at Sunderland Point is remarkable, but it did. It is in fact a type of kapok tree, which still blossoms in the summer.

On the other side of the headland is Sambo's grave. It is said that Sambo came into Sunderland Point with his master on board a sailing ship. Whether he was a slave or not is unclear, but local tradition has it he died at Sunderland Point and was buried close to the sea. The grave is

still there and bears the inscription '*Here lies poor Sambo, A faithful negro who attending his master from the West Indies, died on his arrival at Sunderland*'. The grave is well sign-posted and has flowers placed on it by the local children.

## EDWARD KELLEY – NECROMANCER OF WALTON-LE-DALE

In the year 1560, three astrologers met in Preston for the macabre task of raising the dead. They were Dr John Dee, Warden of Manchester, Edward Kelley, his assistant, and Paul Wareing of Clayton Brook.

The scene is set. The churchyard of St Leonard's Church in Walton-le-Dale at midnight. The moon is shining brightly. The men approach with the intention of raising the dead to try and locate a quantity of money hidden by the deceased before his death.

The men start their gruesome activity. First they dig down into the grave and remove the coffin lid. Then by various incantations, they are able to 'animate' the body again. The body then rose out of the grave and stood upright before them and told them what they wanted to know. It also predicted several happenings in the neighbourhood which are supposed to have occurred according to the dead man's predictions.

It is not recorded how they got the spirit to return to the grave, nor if they ever found the missing fortune.

## THE UNSWORTH DRAGON

It is hard to imagine a dragon terrorising the good people of Unsworth. Today, Unsworth is sandwiched between the M66 motorway and an enormous residential area, part of the Metropolitan Borough of Bury – a place you might well imagine is lacking both tradition and legend. Unsworth Hall, now the Club House for the Unsworth Golf Club contained a carved oak table and panel which illustrated the legend.

Thomas Unsworth was greatly troubled by an enormous dragon which presumably roamed the district at will. These great carnivorous beasts had a particular appetite for women and small children, so something had to be done. Shots were fired at the dragon, but its scales simply deflected the offending missiles. Thomas Unsworth modified his gun so that it would fire his dagger at the dragon. As the dragon rushed forward to consume its latest victim, it raised its head. This was the chance Thomas had been waiting for: he fired the gun and mortally wounded the dragon under the throat. The dragon was no more.

## WINWICK CHURCH AND THE TALKING PIG

A pig was seen running away from the site of the new church being built to commemorate St Oswald who according to one legend was killed here in 642. As it ran away, it was heard to scream *"We-ee-wick, we-ee-wick, we-ee-wick"* from whence the town, according to this particular legend, got its name. The pig then took up a stone in its mouth and carried it to the spot where the church should be built. This remarkable animal apart from talking, then moved all the stones the men had laid to the new sacred site. *'In support of this tradition there is a figure of a pig sculptured on the tower of the church'*. According to another source

however, it is the pig of St Anthony that is preserved in the west front of the church.

## THE GIANT OF WORSLEY

Eliseus de Workesley or Worsley is recorded as being one of the first of the Norman Barons to join in the Crusades. Like all good heroes of legend he fought various giants, Saracens and dragons with great success. On arriving at Rhodes he took on a little more than he could chew. He fought a venomous serpent that was terrorising the district. However the serpent managed to 'sting' the noble Baron and he died and was buried on the spot. Tradition has it that he was a giant who had fought in many duels and combats.

## THE LEGEND OF SIR TARQUINE &
## THE MERMAID OF MARTIN MERE

It may seem surprising that Lancashire should have a legend which involves Sir Lancelot of the Lake. The story, which is much confused goes something like this: Sir Lancelot's mother was forced to flee from her enemies in France and came to Lancashire, where whilst attempting to save her husband's life, left her baby Lancelot by the side of lake called Martin Mere. However, a nymph called Vivian, for reasons best known to nymphs, took charge of the infant and when the Queen returned to collect the child, the nymph disappeared into the lake complete with Lancelot.

Magic is clearly involved as Lancelot survived this ordeal in a Lancashire lake, and by eighteen years of age he was Knighted at the Court of King Arthur as Lancelot of the Lake. As was the way of Knights, they went around fighting battles, dragons and nasty Knights.

There are several accounts of such a knight living in or near Manchester. The most concise account is given by Hollingworth in his 'Manchester Chronicles'.

*'It is said that Sir Tarquine, a stout enemy of King Arthur, kept this Castle (in Manchester) and near to the ford in Medlock, about Mab-house, hung a basin on a tree, on which basin whosoever did strike, Sir Tarquine, or some his company, would come and fight with him; and that Sir Lancelot de Lake, a Knight of King Arthur's Round Table, did beat upon the basin – fought with Tarquine – killed him – possessed himself of the castle – and loosed the prisoners'.*

Another version with a very imaginative poetic form says the tree was laden with weapons from captured Knights and it was one of these weapons which Lancelot used to slay Tarquin. There was also the customary 'beautiful maiden' who was said to have helped Lancelot to release the Knights held captive by Sir Tarquin, who in one account is described as a giant. The young maiden also showed Lancelot how to lower the drawbridge using a secret horn, and to round off the day, Lancelot then killed a dwarf with the giant's sword. The 'beautiful maiden' then changed into the nymph Vivian and vanished from sight.

Incidentally, the Martin Mere described in the legend is not the site of the Wildfowl Trust near Southport, but an area between Formby and Southport which was drained many years ago and is now farmland.

## THE DEVIL AT COCKERHAM

The story of a local schoolmaster and how he might avoid being carried off to hell is told in rhyme, which is repeated here in part:

*Wandering up and down the earth,*
*Midst scenes of sorrow, scenes of mirth;*
*Till at last the Devil tired hard,*
*Alights in Cockerham churchyard;*
*Invisible, but still he prowled,*
*About, and oft at midnight howled,*
*Scaring the natives of the vale,*
*Dwelling in neighbourhood of my tale.*

*The people at length in assembly met,*
*And appointed the schoolmaster the evil to get;*
*To try his skill if he could not master,*
*And with his power the devil bind faster;*
*So proud of his station, and confidence placed in him,*
*He determined to seek and try to chasten him.*

*One day in the school in the corner of churchyard,*
*The windows all fastened, the doors all barred,*
*With the Gypsies blarney, and the witches cant,*
*He drew him forth with his horrible rant.*

*Amazed stood the pedagogue, frightened to see,*
*A spirit in harness from head to knee;*
*With eyes large as saucers and horns on his head,*
*His tail out behind, a dread shadow he shed.*

*All silent he stood, the master quaked more,*
*And tried to move, as if for the door;*
*The spirit his tail gave a wag from behind,*
*Now for his doom! The master made up his mind.*
*"Ay," thought he, "I'm now in a pickle,*
*But wouldn't I mangle him, if now I'd a sickle!"*
*So to put on a bold face, he straightway began -*
*"Who art thou? Answer, fiend or man?"*
*"Know I'm the devil, hear and tremble,*
*And unless thou attendest me, thou'lt soon me resemble;*
*And unless by thy lore thou anon entanglest me,*
*By the shivers and brimstone, mangled thou'lt be."*

*Twas said in a voice as deep as thunder outpoured,*
*Twas a terrible sound, as a lion had roared,*
*Aghast stood the master, his limbs oscillating,*
*Too frightened to speak, or to think, contemplating!*
*"Quick," said the devil, "three questions thou must put,*
*Or otherwise off with me thou must to my hut."*

*This chap more in a terrible flutter,*
*His voice now had gone, he could only mutter;*
*At length, after thrice essaying, he thus began -*
*"Tell me kind sir," (O Moses! How wan*
*was the countenance as he begun) -*
*"How many drops of dew on yon hedges are hinging?"*
*The devil and imps flew past it swinging;*
*He numbered them all. And the man in his walks,*
*Said – "In this field how many wheat stalks?"*
*At one swoop of his scythe, the stalks he all trundles,*
*And bound them up quick in manifold bundles,*
*And gave them the number, as he held them in hand.*

*Now the poor fellows was a pitiful case,*
*As plain might be seen from his long length of face.*
*"Now make me, dear sir, a rope of your sand,*
*Which will bear washing in Cocker, and not lose a strand."*
*The devil and mate then went down to the strand,*
*In a jiffy they twisted a fine rope of sand,*
*And dragged it along with them over the land;*
*But when they brought the rope to be washed,*
*To atoms it went – the rope was all smashed.*

*The devil was foiled, wroth, and gave him a shaking;*
*Up he flew to the steeple – his frame all a-quaking.*
*With one horrid frig – his mind very unwilling,*
*He strode to the brig o'er Broadfleet at Pilling.*

## THE DEMON OF HOTHERSALL HALL

At Hothersall Hall near Ribchester, another Demon is supposed to be laid under a laurel tree until such time as he can spin a rope from the sands of the River Ribble.

## FIRST JUMBO AT MANCHESTER AIRPORT

Manchester Airport is perhaps not the first place you would expect a legend to be born. Well truthfully, it is perhaps not quite a legend, but the story persists that in the early days of the airport, when the first buildings were being constructed in the 1930s at what is now Terminal A, bones were discovered buried in the ground. Folklore has it they were the bones of an elephant which died and was buried by a local circus. This story has been told and re-told around the airport so many times without confirmation, it has now entered into north-west folklore.

# *3*

# IT'S AN OLD LANCASHIRE CUSTOM

Lancashire is full of old traditions and customs many dating back well before the industrial revolution.

## DONKEY-STONING

Donkey-stoning goes back to the time when people sanded a floor to keep it clean. At one time, almost every working class home had its front door step donkey-stoned, whole rows of terraced houses would have their steps stoned by an army of women. Not only did they do the front door step, but often the flagstone front pavement as well. Another refinement was to use two colours of stone or shade, for example, a cream step and white edge – and woe be tide the man who dared to stand on wet or recently stoned steps or flags!

The rag and bone man would call regularly with his horse and cart shouting *"Rag-bone."* Old woollens were a favourite but any old clothes would do and in return he would give the housewife a donkey stone. It was possible to get stones from the local co-op shop, but the rag and bone man was the more usual place.

The oblong blocks were made of ground stone with other additives including dolly blue. The method was simple, the step or whatever was being stoned was wet first of all with a mop-rag or cloth. The stone was rubbed all over the wet part of the step then, before it had time to dry, it was spread evenly using the fingers or a barely wet cloth. When the stoning had dried it was a clean white or more usually cream colour making doorsteps look very attractive.

There were different types and colours of Donkey stone. In Wigan and St Helens, they preferred white; in Yorkshire, brown; in the Oldham and

Ashton-under-Lyne areas, cream was preferred and in Liverpool both white and brown were in demand. Although donkey-stoning was widely used by the housewife as a replacement for ground grit and sand, it was also used in public houses, and in the cotton mills where it helped to keep down grease on the stairs and other places.

Donkey-stoning and creaming has now all but died out in the north of England. I once mentioned donkey-stoning to a friend from the south who thought, in all seriousness, that donkey-stoning must have been very cruel. Donkey-stoning and cleaning generally was cruel, hard work for those involved, but not quite in the way my friend meant.

## CLOGS AND SHAWLS

The popular image of a Lancastrian is of a man with a cloth cap and clogs, taking a whippet for a walk. Women fare no better, they have clogs, long dresses and shawls. Yes, there were men and women like that, but they have long gone and there never was anything romantic about the clatter of clogs as they made their way to the mill in the rain at 6 o'clock in the morning.

Clogs were probably introduced from the continent by Flemish immigrants and soon became an almost standard footwear in the cotton mills and workshops of Lancashire. When they were worn for Sunday best, they were often very ornate with intricate patterning, but unlike the Dutch clog the uppers were made of leather, while the sole remained wood.

The bottoms of the clogs had either rubber strips or clog irons, which the local lads made spark on the stone pavements. Clogs are still made and are available at specialist outlets, mainly as curios rather than practical footwear.

## STANG RIDING OR RIDING THE STANG

Being unfaithful to one's partner in Blackburn in the 19th century could result in the offender being subjected to the ignoble practice of stang-riding. When a man or woman was found to be unfaithful, a framework consisting of two long poles and flat board acting as a seat, was produced. In Flixton, they used a ladder, but the purpose was the same. The offending person was caught by the crowd and tied to the

seat. A procession then started off, the unfortunate culprit being carried high by four men. The crowd contributed to the Pandemonium by banging pots, pans, tea trays etc, as they pass along.

## CEREMONIAL ARCHES

Ceremonial or Triumphal Arches seem to have been a feature of Victorian life. Two of the more noteworthy were at Lancaster and Manchester.

In Lancaster, special ceremonial arches were erected at the top of Penny Street and Meeting House Lane to celebrate when some local gentleman had been appointed High Sheriff of Lancashire. The arches involved using many coloured flags, bunting, streamers and foliage and were often very lavish.

In Manchester a special triumphal arch was constructed from fire engine ladders by the fire brigade when Queen Victoria came in 1894 to officially open the Manchester Ship Canal.

## MARY HOYLE WELL, NEAR ACCRINGTON

The well has several names: Mary Hoyle Well, Mary Royd Well, Mare Hole Well, May Road Well, Mearhead Well and others and was used as a boundary mark as long ago as the 14th century. An author in 1906 suggested it is a corruption of 'St Mary's Holy Well' as *'pilgrimages were made once a year and there was an annual gathering at the well and a fair'*

Pilgrimages were probably made originally on May Day but later, visits to the well were on the first Sunday in May. Huge crowds arrived from the neighbouring milltowns at sunrise. There was a fair with music, dancing, gambling and illegal whiskey. The fair started around midnight and continued throughout the rest of the day. An old lady recalled that she had been told that young women would wash themselves in the well water *'to make an ugly face beautiful'*. The fair, it is said, *'de-generated in later times to a scene of rowdyism'* and was eventually abandoned because of people muddying the drinking water supplied to several local farms.

## GETTING WED

A common custom particularly amongst women and girls in the textile industry was a ceremony known as 'dressing-up'. The victim, a young

woman about to be married was dressed-up by her friends and workmates, usually on the last working day before the wedding. Dressing-up meant having empty bobbins of cotton tied to their cardigan or coat; balloons, toilet rolls, dummies, rolling pins, and streamers attached with safety pins; a chamber pot (often with an eye drawn inside, frequently on a mirror); nappies pinned to their coats and often a large L-plate attached to their back. In order to complete the humiliation, tin cans, bobbins, and anything that would make a noise were tied to her coat. The girl would then be expected, much to her embarrassment, to parade through the streets, go home on the bus or whatever, much to the delight and amusement of her workmates.

If being humiliated is not your idea of fun, the men in the engineering trade were in for a worse time. This could vary from his private parts being blacked with graphite, through to a ball and chain made in the workshop being fastened to his leg, the key conveniently going astray. Invariably of course, the men would go to the pub at lunchtime to celebrate.

## THE WEDDING

In former times, an 'idle crowd' gathered at the church door for the perry, or a free hand-out of half-pence scattered by the bride. The consequence of ignoring this, was the appropriation of the bride's shawl or shoes.

At Flixton, wedding parties were stopped by women who drew a rope across the road and would not let the party pass until a small token amount of money had been paid.

At Warton Crag was a seat called 'The Bride's Chair' which was used by the brides in the village on the day of their wedding. The ceremony itself is not recorded.

## CHILDBIRTH

Childbirth was a very risky time for women. There was, however, one pleasant custom in which women in 'the childbed' were brought presents by their friends. Presumably, they were practical presents such as foods rather than just pleasant gifts.

Sometimes a Groaning cake was brought by the father-to-be. Groaning cake was a mixture of cheese and cake. The first cut of the cake was taken and laid under the pillows of young women as an aid to sweet-dreams about their lovers or husbands-to-be.

Assuming the lady survived the then awful ordeal of childbirth, in some parts of north Lancashire, all the neighbours and friends were invited round to drink both rum and tea, and presumably view the new born babe. After tea, each visitor is recorded as paying one shilling towards the cost of the session.

## THE TOWNCRIER OR BELLMAN

Today, with newspapers, radio and television the traditional role of the Towncrier to announce news and proclamations, has diminished to the point where very few are left. Those that do remain are deadly serious about their work and competitions are held annually to champion the best crier.

*The Town Crier, Clitheroe*

At one time many towns, if not all, in Lancashire would have had access to a crier, but today, the few that remain announce civic events, and officiate at openings, and dinners. Places still having a Towncrier include the City of Manchester, Preston, Leyland, Ormskirk and Clitheroe. In Scotland the Town Crier was announced by a drum roll, in Lancashire a bell is rung and then the traditional call of "Hear Ye! Hear Ye!" is followed by an announcement.

In 1859 at Accrington, there was a strange occurrence of what is called 'notchell crying'. The Bellman went round the town saying that, from a certain day, a particular man would not be answerable for his wife's debts. The man's wife then employed the crier in the afternoon to say she would not be answerable for any debts which he might contract and that they were up to date with their various owings. She also had publicly announced that he allowed her only five shillings a week for food and lodging, that he was not a 'constant' husband and that had he brought home the money instead of spending it on other women they might be in very different circumstances. On this occasion great crowds followed the bellman, but the record says that the ceremony was gradually giving way to the posting of small placards on the walls of the town or village.

The object of the exercise seems to have been to warn people and traders of the meanness and thriftiness of a particular individual.

## WIFE SELLING

In Haslingden there a fairly common practise in Lancashire, when a wife was brought for sale with a halter round her neck. Wife selling seems to have been used as an excuse for the husband dodging his wife's debts.

## FOOT-RACING BY NUDE MEN

In the summer of 1824, two foot-races were held on Whitworth Moor near Rochdale. In one race, two men ran with only a 'small cloth or belt round the loins'. Six runners were in the other race – all stark naked. It is recorded that there were hundreds, perhaps thousands of spectators, men and women. The account adds 'Races by nude men are not extinct in many parts of Lancashire, notwithstanding the vigilance of the County police'.

## COCK-FIGHTING

Cock-fighting, although illegal, still continues throughout the country. In former years, it was prevalent not just amongst the lower classes but also amongst the upper classes in Lancashire. Many towns and villages had a cock pit, where cocks fought and cash stakes were often high.

Special cock-spurs were fitted to the legs of the birds making injury severe to the opposing cock. There was even a cock match in 1772 between the gentlemen of Yorkshire and the gentlemen of Lancashire. In Liverpool a new cockpit attracted on Easter Monday 1790, 41 cocks at ten guineas each battle, and two hundred guineas, the main.

## BULL AND BEAR BAITING

This was once a common and very cruel sport throughout Lancashire. Nicholls in his *History and Traditions of Radcliffe* writes *'Great was the excitement when the dogs held on to the nose of the bull or the bull pitched the dogs high overhead into the river and especially on one occasion when the bull broke away'*. It would seem that tethering the bull to a ring or stake to be attacked by dogs was an acceptable sport in times gone by.

An account is given in *'Gibson's old country sports'* which describes further this barbaric activity.

*'June 15th 1712. I baited a large bull in the bottom of the new marl pit. He was never baited before as I know of, but played to admiration. There was I think, eight or nine dogs played the first bait and only two the third bait. I think there was not above two dogs but what were very ill hurt. I gave a collar to be played for but no dog could get it fairly, so I gave it to Richard Spencer of Liverpool being his dog deserved it'.*

Not everyone liked such cruelty, in Flixton the alehouse-keepers issued a special notice in 1816, saying they would not encourage *'the savage and brutal practices of bull (and bear) baiting'* at the annual Wakes.

Another variant was badger baiting in which the unfortunate badger was placed in a box with *'a tunnel attached, two or three yards long'*. The dog would attempt to draw the badger out of the tunnel much to the delight of the on-lookers. The badger would then be pulled back a little way and the dog encouraged in its ferocity, attacking the badger until they were both covered in blood. The dog did not always get the best of it and there are accounts of the badger, sadly perhaps, living to fight

another day. Almost a hundred years have passed since that account was given, but some men still think it good sport to bait badgers, not in a box, but by digging them out of their sets.

## PURRIN' AND TUPPIN' – OR UP AND DOWN FIGHTING

In the Bolton area, disputes were sometimes settled in a very odd way. It is said that at every Assizes, men are tried for manslaughter or murder resulting from their contests. (1832)

Up and down fighting appears to be a no-holds-barred bout, in which protagonists squeeze the throat until surrender – or not – as the case may be.

The Judges in an attempt to quell these bouts introduced a radical punishment that on conviction of manslaughter for kicking (purring) the men would be burned in the hand, later this became transportation for life and eventually hard labour not exceeding three years.

The writer of this account added *'it will shortly only be known as a matter of history'*. Yet, from my own childhood, my parents told me of purrin' and tuppin' contests taking place in the Little Lever area. Colliers and other pit workers were the usual opponents in this distasteful practice. Two men would stand face to face. They would grasp one another by the tops of the arms or the back of the jacket. They would then fight, tupping, smashing their forehead into their opponent and purring or kicking their opponent for all they were worth. Colliers invariably wore hard sole clogs or boots and the injuries must have been severe. Purring and tupping often for money, went on in the Radcliffe, Little Lever, Salford, Bolton, Westhoughton and Wigan areas into the present century along with fist fights and wrestling bouts.

## APPRENTICE CUSTOMS

COOPERS. In Liverpool before the Second World War, apprentice coopers coming out of their time were rolled around in a barrel. Some years ago I talked to two different generations of coopers and they told me how the tradition had changed.

*'When you came out of your time there, being near the docks, they would put a lot of flags across the street and any sailor coming up could read the flags that a cooper was coming out of his time.*

*The first cask I made you know, you give that to them* (the firm). *The other coopers, would put you in the barrel and rolled you up and down. Barrels in them days, they used to set fire to them you know, kind of preserve 'em, and you'd get inside that, and the barrel being hot, and they'd just get a can of water and throw it around. It weren't half hot and all. You had a merry time afterwards of course.*

*You had to take 'em all out to a pub and give them a drink and the foreman was on to me for getting them too drunk you know, it cost me three or four pounds and then beer was only three halfpence a pint you know. It took a lot time to save up'.*

The Second World War changed attitudes and feelings.

*' . . . the men objected 'to being made bloody fools of, rolled around the yard with sawdust poured over our heads and then buckets of dirty water and then to add insult to injury you had to take the journey-man coopers out and pay for their beer. We had been the army and we didn't want that and we wouldn't pay for no beer'.*

**ENGINEERING.** New apprentices went through various initiations, some of them dangerous and cruel. At one firm I worked for, it was common and seen as a huge joke to push the head of a new apprentice down the lavatory and then pull the chain. In another nearby works, they would black the boy's private parts with graphite, an almost impossible material to remove.

In a lighter vein apprentices were often sent for a bucket of steam, elbow grease, or a glass hammer. Another common trick was to give the apprentice a pattern-maker's rule, which is fractionally longer than a conventional one.

They were sent for bobbins of Whitworth thread and to the electrician with the question *"Have you got five Amps please?"*

In the foundry, the hapless youth would be sent to the stores and told to ask for a long stand. After thirty minutes of waiting, it dawned on him that he was indeed having a long stand. My favourite, having seen this done, was to stand the boy in a large metal bucket and tell him to lift himself up. This was done to a chorus of remarks such as *'Give it a bit*

*more pull, you nearly had it then'* and *'Go on its gooin', give it a bit more umph'*. It was surprising how many lads believed they could really do it.

In the cotton mills, lads were treated no less cruelly: oil was squirted down the front of their pants and at one firm in north Manchester, the young lad was held down and a metal washer placed on his manhood. Both men and women condoned this appalling piece of merriment.

Printer's apprentices were blacked all over with printer's ink, and at Buckley Wells locomotive depot in Bury, new apprentices were *'fitted out for the road'* with coal in their pockets and well-watered.

Solicitors' offices were not exempt from such initiations, a young girl might well be sent to the post office for *'verbal agreement stamps'*.

## BELLS

Bells were often sounded at funerals, it is said that it was the custom until the 1830s to *'ring a merry peal of bells'* as soon as the interment was over. Another form of this in Lancashire was apparently the ringing of the passing bell to conclude with nine knells of the clapper for a man, six for a woman, and three for a child.

There used to be a bell rung on Shrove Tuesday to call the people together to confess their sins, others in Lancashire simply called it the Pancake Bell. It was used in Poulton in later years to signal operations for Pancake making.

The Curfew Bell, as far as I can discover, is no longer tolled in Lancashire. But in times past, it was heard in Burnley, Colne, Blackburn, Padiham and Middleton near Manchester.

## THIRTEEN O'CLOCK

At Worsley near Manchester, the parish church still strikes thirteen at one o'clock in the afternoon. There is no real deep tradition in this, it was simply a clever modification undertaken by the Duke of Bridgewater to ensure that his workmen knew, and had no excuses, that it was one o'clock and time to start work again.

## TRADITIONAL LANCASHIRE FOOD

It is of course possible to write a complete book on the subject of Lancashire food, and simnel cake and other foods have already been mentioned elsewhere. Bury market is famed for its black puddings, as is Cowman's butchers of Clitheroe. Cow-heel and tripe was regularly on the family menu on all over Lancashire; in Bolton, it was pigs' trotters and in Oldham, chitterling. There was nothing better my mother said, then a good sheep's-jimmy, or sheep's head. My job every Friday was to collect a sheep's head from the butchers and bring it home wrapped in newspaper, the blood from the cleaved skull seeping through the outer layers of news. That lasted several days, from it came stew, broth, tongue – even the brain was used – there was little left to pick by the time the skull arrived at the dustbin.

On the sweet side, there were Eccles, Goosenargh and Chorley cakes. Ormskirk had its gingerbread and Manchester its tart, Everton toffee and from Wigan, Uncle Joe's mintballs. Still on the therapeutic, it is possible to find Fisherman's Friend made in Fleetwood, in drug stores as far away as Salt Lake City in America.

Fish and chips is a standard northern dish, good value and nourishment, with or without Curry. Lancashire hot-pot is internationally known, and lobscouse, a dish adopted by Liverpudlians, is in fact Norwegian in origin, presumably introduced by sailors.

Havercake or oat cakes were delicious with butter and an oat-meal bread called Jannock was also a popular food.

# THROUGH THE YEAR . . .

Many traditions and customs occur only at particular times of the year. Changes in the calendar have resulted in confusion as far as traditions and customs go. Many small villages simply ignored the calendar changes and carried on as usual. This plus the effect of the Church has left us with quite an array of traditions and customs over the year.

# JANUARY, FEBRUARY, MARCH, APRIL

## New Year's Eve & New Year's Day Customs

As small children, we were told on New Year's Eve to look for the man with as many noses as there are days of the year. Of course, as children we searched in vain for the remarkable man with 365 noses.

In Liverpool all the ships sounded their hooters at the stroke of midnight, the chorus going on for anything up to half an hour. Church bells, muffled before 12 o'clock would ring in the New Year at some rural churches such as at Higher Walton near Preston.

In many parts of Lancashire it was customary to leave out a small present, usually for a child, on New Year's morning. My parents used to have me leave a shoe at the foot of the stairs or at the back of a door and in the morning there would be some small token, a block of chocolate or some coins.

## PLOUGH MONDAY

Plough Monday was the first Monday following twelfth night and was celebrated on the Lancashire coastal plain mainly in the rural areas. A group of farm hands would drag a plough along the village street. Every so often they would stop and a sword dance would be performed. One member of the group was dressed as an old woman and the other clad in skins with an animal's tail hanging down his back. These two members of the group collected money during the dances. If someone failed to give any money, they were quite liable to have their garden or path ploughed up!

## ST OMER'S GAMES, STONYHURST

The boys at Stonyhurst College at mid-Lent had a custom which dated back to the establishment of the college in Spain. They would carry out the custom of '*saw-the-witch*'. A figure of an old woman was carried out of the college '*according to Spanish custom*' then cut in two which indicated that the penitential season was over. The whole of the proceedings is recorded as being rather boisterous, one somewhat less than passive observer remarking that '*Mr Oates was among them and I was one of them that broke a Pan about his head for Recreation*'.

## BRAGOT OR MOTHERING SUNDAY

Bragot was a kind of spiced ale. It was popular in Bury during Simnel Sunday and in Leigh during Mothering Sunday. It is recorded that some boys used to attach pieces of coloured cloth to the gowns of women attending the church in Leigh, a practice reminiscent of a custom once found in Portugal. On Mothering Sunday, it became customary to visit one's parents, bragot ale being replaced in Lancashire by mulled ale, for which there was a considerable demand.

## THE ASHTON GYST ALE CELEBRATIONS
## (LADY DAY, 25TH MARCH)

The gyst ale or guising feast was once an annual festival in the town of Ashton-under-Lyne. The Lord of the Manor, Sir John Assheton, received in 1422 the sum of 20 shillings as Lord of the Manor for the privilege of holding the feast. The guising (more properly disguising) was celebrated in the spring after the fields had been dressed with marl ready to sow wheat. At one time these feasts also known as marlings, were common all over Lancashire.

The Lord of the Manor, the farmer – whosoever the local dignitary was, came forward to start the proceedings by announcing the sum he intended to give towards the Feast. The treasurer of the feast then exclaimed *"a largesse!"* (From French, presumably meaning in this context a benefactor, someone giving generously, a distribution of gifts) The populace demanded in a loud voice, *"From whom?"*

The donor, whoever it happened to be, was entitled Lord for the occasion and would say he had contributed at least several thousand pounds, which was of course quite untrue. Nevertheless at times, quite large sums of money were pledged or 'donated'.

Others then followed his example from all spheres of local society, each one stating their intent. When the collection had been completed, an immense garland of flowers bedecked in ribbons, was formed on a special wooden frame. The frame had hooks and a large collection of watches, jewels and silver items were hung for all to see.

The garland was then carried through the streets by the local townspeople dressed in their finest attire. They were formed into a procession by master of ceremonies known as the King. The Fool was

also there in his grotesque cap, hideous grinning mask, with his tail hanging to the ground with a bell tied behind which he would ring when he wanted to make an announcement or draw attention.

It is said that, in earlier times, the Fool was mounted on a Hobby Horse and had quite a lucrative role, even if he did have to pay a commission to the Lord of the Manor for the privilege of hob-riding. There was at one time intense rivalry between neighbouring towns to see who could produce the best hob-rider, with often ludicrous amounts of money being spent.

## SHROVETIDE

Originally Shrovetide was the name given to the last few days before Lent in the church calendar. People would make their confessions before entering the great fast of Lent which began on Ash Wednesday. As soon as they had made their confessions they were permitted to feast. One lady summed up the tradition rather nicely in the following words:

*'Pancake Tuesday and Ash Wednesday, it was case of eating up all your rich food, eggs and milk and butter. On Ash Wednesday, it was sort of a fasting day, poverty meals supposed to be really'.*

Three days have particular significance in Lancashire, Collop Monday, Pancake or Shrove Tuesday and Fritters Wednesday. Collops originally were slices of bread, later it became traditional to have rashers of Bacon, and in Rishton where they observed Collop Monday until very recently, bacon and egg was the meal of the day.

Fritters were not quite like the variety advertised on television, but were thick, soft cakes with sliced apple intermixed.

## COCKFIGHTING

Manchester Grammar School around 1525 made an effort to abolish cock-fighting at Shrove Tuesday.

*'The scholars . . . shall use no cock-fights, nor other unlawful games . . . which shall be to the great let of virtue and to charge and cost of the scholars, and of their friends'.*

At Clitheroe Grammar School, an annual present was expected from the pupils at Shrovetide, the amount varying according to what could be

afforded by the parents. With the exception of this so-called cock-penny, the school was free.

Cock-pence were also paid towards the headmaster's stipend at Burnley Grammar School, but it is recorded that the practice degenerated into a general whip-round for a good time.

## PANCAKE TUESDAY OR SHROVE TUESDAY

Pancake Tuesday or Shrove Tuesday is still celebrated all over England, with Pancake Races and Pancake Tossing Competitions. In some places in Lancashire, they even tossed fritters rather than pancakes. In north east Lancashire, children went from door to door asking for pancakes *'Please – a pancake'* and at Whittle-le-Woods children blacked their faces before they set off in search of pancakes.

At Poulton on the Fylde, the pancake bell was rung at 11 a.m. at the church and was a signal for tossing or throwing the pancakes. Shrove Tuesday was the one day of the year when children by tradition could 'demand' a holiday. Something of this barring-out tradition is preserved in the rhyme:

*Pancake Tuesday is a very lucky day,*
*If you don't give us a holiday we'll all run away,*
*Where will you run to? Up Black Lane*
*When you all come back, you'll get the cane.*

Engineering and other trade apprentices would leave their workplace carrying bags of soot and graphite and then parade through the streets bringing out other apprentices *en route*. At Robert Hall's Foundry in Bury, the apprentices had soot-bag fights, and in nearby Radcliffe, the apprentices hit trams and cars and generally made a mess with their bags of blacking. In Rochdale the foremen have been known to nail the jackets of the apprentices to the benches in order to keep them at work.

Many traders, especially those dealing in food-stuffs, resented the filthy apprentices going into their shops and making a mess. A lot of damage was also occasioned to cotton in the mills, with the result that the tradition died a very quick death in the 1980s.

## ASH WEDNESDAY

The Lent fast was harsh, abstention was expected from meat, cream, cheese, and wine, with only one meal in the evening. I cannot personally recall any abstinence, my own mother insisting that Ash Wednesday was the day to have potato hash. Which we did.

Certainly, it was expected as children that you went to church on Ash Wednesday morning, the rest of the day being your own. It is still common in the Catholic Church on Ash Wednesday to have a cross marked on the forehead in ashes and water, as one old lady recalled: *'My boss was a Catholic and he came to work and I told him he had a dirty mark on his forehead. Yes, he said, I've been to church'.*

## SIMNEL SUNDAY

In Bury in mid-Lent, it was customary to have simblin cakes. These cakes were readily available from local shops which kept open all day Sunday except for the time when the morning service was being held. The cakes are made from currants, candied lemon, sugar, spice, all sandwiched between crusts of short or puff-pastry. The cake was in great demand in Manchester and the surrounding area as well as in Bury.

I can well recall my older relatives treating me to simnel cake on Simnel Sunday. One of the characteristic constituents of their cake was caraway seeds, which always stuck between your teeth. It is best described as a rich fruit cake *'rather like a Christmas cake with a layer of almond paste in the middle, just almond paste on top and all around the edges you made little bows of almond paste and put them round like eggs'.*

## FAG-PIE SUNDAY

The idea of eating a pie made of fag-ends is not very appealing. Yet Fag Pie was eaten in the Burnley area, the second Sunday before Easter, or as it falls between Mid-Lent and Palm Sunday. The Fag in question is in fact Fig. The pies were made of dried figs, sugar and treacle resulting in a sickly dish. In the Blackburn area, Fag-pies were prepared for Mid-lent Sunday and visits made to the houses of friends to eat the pie.

## EASTERTIDE

Easter is a movable feast and follows the first full moon immediately after the 21st March. It is a time of year traditionally for a great deal of merry making.

For example in Padiham, in Sunday, Monday and Tuesday of Easter week, a game called the Easter Game of the Ring was played. The rules and objectives of this game are not clear, but a group of young people form themselves into a ring and then tap each other repeatedly with a stick. Other variations in the Manchester area, apparently include dropping a handkerchief at the foot, and taps with the hand.

## GOOD FRIDAY

Apart from the established traditions of the church, around Good Friday still sees the sale of hot cross buns in the confectioners. In some places it was once believed that hot-cross buns preserved from one year to the next would prevent whooping-cough. In Mossley, it was customary to eat fish on Good Friday, the fish shops remaining open especially for this purpose.

In some places, Good Friday is also known as Cracklin' Friday. Children went around the neighbourhood carrying a little basket to *'beg'* small wheat cakes. The original of this seems to come straight from a Biblical text *'Take with thee loaves and cracknels'*. (*I Kings xiv*)

In other places, Good Friday was treated more like a holiday, for example – there was fair at Daisy Nook near Oldham, and others would climb local hills such as Pendle and Rivington Pike.

## JUDAS BONFIRES

On Good Friday, groups of children in the Roman Catholic part of Liverpool paraded about with stuffed sacks made up to look like the human figure of Judas. Children would get pig's bladders from the local butcher, dry them out and hit the Judas with them. It has been suggested that the custom was Spanish in origin; originally these effigies were held aloft on long poles, the children knocking on bedroom windows for coppers. The effigy was then burned on a bonfire in the early morning as a reminder of Judas' betrayal of Jesus.

# OLD BALL

In Blackburn and Burnley, a crude representation of a horse's head is made, the eyes being made out of the bottoms of broken wine bottles or similar black-bottomed bottles. The teeth are made of huge nails, the lower jaw being movable and controlled by the operator. The whole thing is on a long stick held by the person working Old Ball, who is hidden beneath a large sheet of sack-cloth. A tail projects from the back to complete the illusion. Old Ball then runs at the crowd pretending to be a horse, he snaps his jaws and sometimes fingers were injured as he snapped his teeth together, thus making the women and children scream. It seems to have died out in Blackburn by the 1840s although it was still to be seen in the Swinton and Worsley areas of Manchester.

Not far away in Barton, the Easter Hobby-horse as it was known, was somewhat less dangerous. It had an enormous tongue of red flannel and terrorised the people of the village, chasing them around. It is recorded that the shop-keepers of Barton locked up their doors, as the pace-eggers were liable to help themselves to *'tobacco or drink'* and any resistance was met with a punce in the shins or similar.

# BRITANNIA COCONUT DANCERS

Coconutters dance their way through the streets of Bacup in the Rossendale Valley every Easter Saturday, come rain or shine accompanied by the Stacksteads Brass Band. The men have blackened faces, wear a kind of white mob cap with coloured stripes, a rosette, a black tunic with a white sash, and a white kilt with horizontal red stripes. Their breeches are also black and they wear clogs on their feet and white socks. Strapped to their mid-rifts and hands are flat wooden discs which they click together during the dance. These discs presumably remnants of coconut sections used in by-gone days. They have a several dances including a garland dance in which red, white and blue paper garlands are used. It has been suggested that some of the workers in the local quarries brought it with them from either Spain or Africa, but the origins, for there were several troupes at one time, is uncertain.

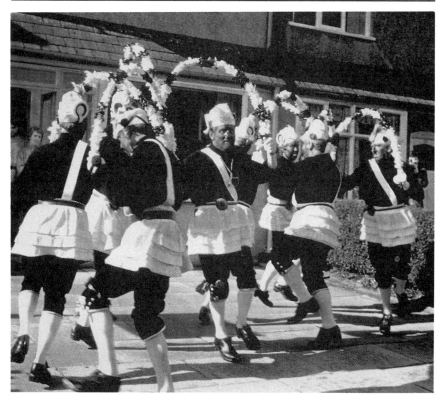

*Bacup Britannia Coconut Dancers*

## PACE-EGG PLAYS

Beware. At Eastertime it is quite possible see a man slashed at with a sword, and then brought back to life! This is the stuff of Easter pace-egg plays. The main players are usually a Fool who hits everyone in sight with a bladder on the end of a stick; St George the Champion of England with his white over-dress and red cross; Slasher, a soldier; the Doctor who can perform miracles; the Prince of Paradine and others as the plot demands including Beelzebub, the devil.

The play often starts with a loud sound such the banging of a drum. The Lancaster Pace-egg play starts with the words *'Here's two or three jolly lads, all in one mind, we've come a pace-eggin' and we hope you'll prove kind'.* The story involves Slasher who is killed by St George, and then,

miraculously brought back to life by the 'good Doctor' with his magic bottle.

*Pace-egg Play, Rochdale*

On the Fylde at Easter-time was a sword or morris dance which seems to have been a combination of Pace-egging and Morris, known as Ignaging and Ignagnus. There was a Grand Turk, St George, and the inevitable fight, with a good doctor present who was capable of bringing the victim back to life.

Bury retains its pace-egg play, as do Lancaster and Midgley on the Lancashire and Yorkshire border near Hebden Bridge.

In Blackburn pace-egging commenced on the Monday and finished on the Thursday before Easter-week. Young men – as many as twenty – are dressed up in masks and dramatic cloths. They then went round to

every house accompanied by a fiddle, dancing and singing. The men tried to disguise their voices as much as possible, the person they visit trying to guess who it really is.

The characters varied enormously, from Macbeth, Richard III, a black footman, a quack doctor, and Irish umbrella-mender, and even an oyster seller. Their reward for their trouble was a supply of wine, punch or ale from the householder.

This apparently innocuous occupation was however subject to several brutal attacks from the so-called Carr Lane gang in the Blackburn of the 1840s and there were lawless fights. The whole thing ended with tragedy when one unfortunate young man had his skull fractured and died.

Children went from door to door with little baskets dressed up in coloured paper and ribbons, receiving at some houses eggs, or hot gingerbread, and at others a few coppers to spend. *'God's sake! A pace-egg is the continual cry'*, said one reporter. In East Lancashire, the baskets were dressed with moss and all gifts were thankfully received. Sometimes, it is reported, the men are dressed in women's clothing and the women in mens. (So, what's new?)

## EGG-ROLLING

At Easter, children today have chocolate Easter-eggs, but in former years real eggs were used and decorated. In some parts of Lancashire children would go round and beg eggs for Easter dinner singing a little song.

Eggs were also used in other ways. In days before brown eggs were common, they were hard-boiled with onion skills or whins to give them a colour, then decorated by painting. The eggs were then rolled down a slope until they broke. On Easter Monday at Avenham Park in Preston, hundreds of people still roll their eggs and at Holcombe Hill there were even special trains from Bury bringing crowds of people to roll eggs and climb the hill. In Rochdale, the custom was known as Bowl-egg Sunday. In some places there were organised bowls with a line marked out at a set distance, the winner being the best bowler over the line. Elsewhere, *'boys would throw the eggs up in the air like throwing a ball'*.

In Blackpool, there were crowds of people rolling their eggs down the sandhills near the promenade. So many in fact that, at one time, special

trams were operated to convey people and, on the flatland of Fylde, Presall Hill was pressed into service.

## LIFTING AND HEAVING CUSTOMS

A custom which has now died out was lifting and heaving. On Easter Monday the men lift the women and on Easter Tuesday, the women lift the men. The tradition which one writer described as a *'very objectionable custom'* was practised in a number of places including Warrington, Blackburn, Liverpool, Bolton, Whalley, Downham, Clitheroe, Eccles, Manchester and Radcliffe. This strange custom seems however to have had religious roots. *'Lifting was originally designed to represent our Saviour's resurrection. One or more take hold of each leg and one or more of each arm, near the body, and lift the person up into a horizontal position three times. It is a rude, indecent diversion practised chiefly by the lower class of people'.*

At Downham, it is also recorded that *'parties of eight or ten women running after and lifting or heaving men on Easter Tuesday. The men lift the women on Monday and vice versa on Tuesday'.*

One account of this strange custom says *'On Easter Monday between Radcliffe and Bolton, we saw a number of females surround a male, whom they mastered, and fairly lifted aloft into the air. It was a merry scene . . . The next day would bring reprisals: the girls would then be the party to be subjected to this rude treatment'.*

Later in the Manchester area they introduced a 'heaving chair' which was preserved until fairly recently in Liverpool.

## EASTER AT MANCHESTER GRAMMAR SCHOOL

At Manchester Grammar School in the early part of the 19th century, there were various festivals at Easter. On Easter Monday, the masters and scholars assembled in the schoolroom with a band of music and banners. Manchester in those days was very different and the Grammar School was situated close to Hunts Bank near the present Corporation Street and Victoria Railway Station.

The procession would set off led by clergymen from the nearby collegiate church, churchwardens and masters of the school, the band playing various popular tunes. The parade made its way to a garden near Walker's Croft, to a site almost certainly now buried beneath

Victoria Station. It was here that targets were set up and 'artillery practice' as it was called, took place using bows and arrows. The prizes were silver buckles suspended in the target frame and a 'dung-hill cock'. After the prizes had been awarded at the end of the day, the procession made its way back along Hunt's Bank, Fennel Street, Hanging Ditch, and Old Millgate to the Bull's Head in the Market Place. Here the junior boys were treated with frumenty, a popular northern dish.

The constituents of frumenty varied but the one eaten by Manchester Grammar Boys appears to have had raisins, currants, and spices all boiled together in milk. It is likely that wheat grains were also used along with an appropriate amount of alcohol.

## LANCASTER TOY-GIVING OR THE WILLIAM SMITH FESTIVAL

An Easter custom arose in Lancaster when local children met on Easter Sunday to play games and sport on a field known as Giant Axe Field. However, there was a certain disquiet about using the Sabbath in this way. In 1897, William Smith a former Mayor of Lancaster announced he would finance a festival for the children and they would all receive a small gift. On Easter Monday, the children assembled in the Market Square and walked in groups to the Market Hall where they received toys or small gifts. In the afternoon they went to the Giant Axe field for sport and games.

## RIDING THE BLACK LAD AT ASHTON-UNDER-LYNE

One of Lancashire's most curious of customs was the pageant of Riding the Black Lad held annually on Easter Monday at Ashton-under-Lyne until the 1950s. A procession was held in which a man or a boy was dressed in black armour and mounted on a horse, followed by men at arms and then men and women in contemporary costume. The custom seems to date back to at least to the 18th century, and probably earlier.

Originally, there was an effigy of a man in straw placed on the back of the horse. At the end of the journey, he was removed from the horse and made a target for all and sundry to discharge their weapons at. Another account says that the effigy was flung into a pool after being hung on the old Cross and then missiles were thrown at the dummy. On other

occasions the effigy was burnt to the great delight of the assembled crowd.

*Black Knight, Ashton-under-Lyne*

During the last quarter of the 19th century, William Axon wrote a special booklet about the Black Knight of Ashton, having made a special trip to the town to see the pageant for himself. His account makes fascinating reading.

*'The streets were thronged with people all bent on enjoying themselves. In the market ground was the usual spectacle of a Lancashire Fair.*

*Once or twice we heard the sounds of music in the distance and saw crowds hurrying off in search of the sounds which they knew heralded the appearance of the Black Knight. We soon saw marching down the middle of the street a motley*

*band, after the musicians came the figure of the Black Lad. He or rather it, had on a dragon's helmet and cuirass and armholes of the latter being stuffed with long tufts of heather. Red trousers, suspiciously suggestive of internal sawdust, completed a not very august figure. His black-lad-ship only getting astride his horse once a year, evidently had lost some of his skill as a rider. Accordingly, a man in a faded red livery sat on the horse behind the gallant knight, and with his lithe arms clasped round the burly worthy. The retainers of the knight rattled tin cans under our noses, to show that we acknowledged fealty, they passed on to our neighbours, reaping, if not a golden, at least a substantial copper harvest.'*

The Ashton Reporter in April 1884 reported that there was:

*"A brass helmetted effigy, stuck on the back of a large cart horse with elephantine legs . . . The second 'competitor' rode about in a gig, in which he leans far back and displaying, perhaps, the best got-up habiliments and perhaps the best idea of what Sir Ralph Ashton really was in his panoply of armour.*

*A third knight was elaborately got up to represent Osman Digna. This was quite a new effigy . . . but the Chieftain's costumier either had a very hazy idea of how to dress an Arab chief or was hampered by an exceedingly limited supply of materials.*

*We found that there were at least three knights guild riding; and it was as difficult to distinguish true from false, like good vassals we paid allegiance to each. The one already mentioned was rudest in structure. Another one was sumptuously dressed, had a velvet cloak and helmet with nodding plume; it held a naked sword in one hand and in the other a bunch of corn marigold. His friends appeared to be doubtful of his memory, and so had embroidered on his velvet mantle the initials of his name."*

At every public house the good knight called, and the tapsters appeared willing enough to pay the tax of foaming tankards which the visit entailed.

In modern tin.^s, Riding the Black Lad, became more of a carnival. There was a long procession of floats and tableaux led by Tintwistle Prize Band and the Mayor and Mayoress of Ashton whose job it was to crown the Black Knight Pageant Queen. There were former pageant queens, mounted police, and of course the black knight himself mounted on a horse. The Knight was represented by a real person with a visor and black doublet, followed close behind by a band of pikemen. Next came school children in various costumes, and tableaux including the slaying

of the dragon by St George, Britannia with golden helmet, Indian braves, railway horses with gleaming brasses, a motor parade, and trade exhibits including one from Jones's sewing machines of Audenshaw. Prizes were given to the best in each class.

It seems likely that originally there was a suit of black velvet and a coat of mail, hence the Black Lad. Various accounts suggest that the memory of Sir Ralph Ashton was perpetuated so that people would not forget his severity on the local people, although there is no evidence for this. Another account suggests the velvet suit was presented to Thomas Ashton for bravery by Edward III, and the custom was installed to perpetuate his valour.

Sir Thomas de Assheton III was known to be an alchemist. Perhaps this was reason enough for local people to fear and rebuke him? After all, look what happened to witches!

Modern folklorists have a different interpretation of events. They suggest that the custom is pre-Christian in origin and may represent the ending of winter, the people taking control and destroying an effigy in order to herald in spring.

# MAY-TIME

## MISCHIEF NIGHT

In the Burnley area, the 30th April or the day before May Day, was generally known as Mischief Night. Children tied door handles together, shop signs would be exchanged, chimneys blocked up, windows rattled on and other generally annoying things such as the removal of garden gates from their hinges. Young men would place trees, shrubs, or flowers under various windows or near doors. All these have specific meanings, for example, a thorn means scorn, a bramble for those who like to ramble, oak for a joke, a wicken for my sweet chicken and so on.

Curiously though, Mischief Night was also celebrated in more recent times on the 4th November and has become confused with the American introduction of 'Trick or Treat'.

## MAY DAY RITUALS IN PENDLEBURY

In Pendleton, they had a Maypole which was in use in the 14th century. The Maypole was dressed with '*verdant boughs brought from Blakeley Forest*' and topped with a royal crown. The people would dance and sing around the Maypole and then feast.

Maypoles were still commonplace in the 1950s, in the streets of some towns and certainly in schools. The town Maypole in Clitheroe for example, was in the Castle grounds. Today, the Morrismen are reminiscent of May Day, and the only large Maypole gathering that is known to the author is at Knutsford in Cheshire.

*Maypole Dancers, Rainscough*

## BRINGING IN MAY

On the Fylde, many youngsters risked life and limb placing boughs on chimney tops of their neighbours' houses. A King and a Queen with Royal attendants and a band, along with mummers, attracted people

from far and wide. There were pageants, sports, games and dances, everyone having a good time. In Poulton in the 1780s, the causeways were strewn with flowers and at the door of each 'respectable' inhabitant there were sweetmeats, ale and even wine.

## MAY SINGERS

In some parts of south Lancashire and north Cheshire, bands of men would go round for the purpose of 'singing in May', another good excuse to collect alms for good ale.

## A MAY PENNY

At Clayton Bottoms near Preston, the squire from Leyland gave the local children a penny on May Day.

## ROBIN HOOD AND MAY GAMES IN BURNLEY

Things were, according to Edmond Assheton, a Lancashire magistrate writing in 1580, out of hand in Burnley with *'lewd sports'* and *'Sabbath breaking'*. Edmond seems to have been something of a spoil-sport, for he says *'a number of Justices of the Peace have consulted as to the suppression of these lewd sports tending to no other end but to stir up our frail natures to wantonness'*, and *'for every man may well know with what minds after their embracings, kissings and unchaste beholding of each other, they can come presently prepared for prayer'*.

## ADEONKONKAY OR ADDY-ADDY-ON-KON-KAY

Groups of boys with blackened faces and false moustaches went around the streets of Blackburn at Maytime. The leader of the group portrays an Italian and the second in the group is covered by an old sack with a noose around his neck, pretending to be a bear. To the tune of 'adeonkonkay', and rattle of tin cans, the bear dances round and performs somersaults.

At Billington, a group of about three lads went adeonkonkay-ing whilst the girls took the Maypole from door to door. One of the boys had a sack over his head with eye-holes cut in, and another boy had a stick rather than the noose. The lad playing the leader said words to the effect of *"Tipple-taily, roley-poley, catch-a-pole, . . . dance."*

At Great Harwood the sack was more refined, a larger area was cut out so the whole face could be seen, but the words were similar "*Catchey-poly, roley-poly, somersault*". Which the boy then did on command.

## THE BIRCHEN BOUGH TRADITION

In Cheshire and Lancashire, it was not uncommon to see a young man place a birchen bough over the door of their intended and an alder bough over the door of a scold!

## SPAW SUNDAY

On the first Sunday in May, local people would go picnicking on the Syke in Rochdale. They would have a stick of liquorice and place this into a bottle filled with spa water from the fell side. According to an older version of events, young people would meet at Knott Hill in the Spotland area of the town to present their congratulations on the arrival of the season.

## DRESSING UP HORSES

May Day was a special day for those owning horses. Many Lancashire towns had horse parades or owners dressed up their horses with ribbons and horse-brasses. In Radcliffe, I recall the milk being delivered in the 1950s by horse and two-wheel dray. On May Day, I was ushered out of the house to see the horse with my mother saying '*It'll be something you can tell your children about. They'll not be doing it for much longer.*' The horse had shiny brasses all down the front, gaily coloured ribbons and many rosettes attached to the harnesses. The undignified rear end was catered for with a beautifully-tied bow of coloured ribbon on the tail.

In Clayton-le-Moors on May Day, '*every horse that come up road were trimmed up, rosettes, and their manes plaited in with ribbon, and their tail plaited with the ribbon. There were the milk cart and happen the coal cart, Applebury's flour, and on May Day they all cleaned up their horses, cleaned them up and trimmed them up.*'

In Liverpool and Birkenhead, men used thousands of horses in the transportation of goods to and from the docks. On May Day the carters and drivers put on their best suites, covered with white linen slops and sport new whips in honour of the occasion. The carts in many cases are

dressed with the actual goods in which the owners deal. *'Real and artificial flowers are disposed in wreathes and other forms upon different parts of the harness – brilliant velvet clothes worked in silver and gold are thrown over the loins of the horses and if their owners are of sufficient standing to bear coats of arms, these are emblazoned upon the cloths . . . A few years ago the Corporation of Liverpool exhibited no fewer than 156 horses in the procession, the first cart containing all the implements used by the scavenging department most artistically arranged. The railway companies, the brewers, the spirit merchants and all the principal dock carriers send their teams with samples of produce to swell the procession. After parading the principal streets headed by bands of music and banners, the horses are taken home to their respective stables and public dinners are given to the carters by the Corporation, the Railway Companies and other firms.'*

Recently, the Liverpool Horse Parade has been successfully revived despite the decline in horse numbers and the mass use of motor vehicles. In Blackburn, Thwaites Brewery still maintains a horse and dray which undertakes local deliveries and also attends agricultural and other shows representing the company.

## MAY-DAY IN MANCHESTER

In Manchester in former times, the coaching enterprises such as the Royal Mails turned out their spare vehicles and horses for a grand procession through the streets. *'Many of the coaches were newly painted, the teams having new harness and gearing, the coachmen and guards having new uniforms. The coachmen and rivers wore great cockades of ribbons, and there were huge bouquets of flowers. The guard in bright scarlet uniform would blow on his bugle some popular tune and the horses wore cockades and nosegays about their heads and ears.*

*Almost every coach on this occasion was drawn by four horses, their coats shining with an extra polish for May Day; and the cavalcade was really a pretty sight on a bright May Day morning. Second only to it in decorative splendour, and in horseflesh was the display of lurries, waggons, drays and carts, with their fine draught horses. Then came the milk-carts with their drivers covered in ribbons'.*

## MAY QUEENS

Girls would dress up as May Queens and go around the streets singing, sometimes for money. In Radcliffe around 1900, there were a May King

and Queen, and in Bury children would dress up in white with a wreath and a veil, usually made from mother's old lace curtains. The lads blackened their faces and collected the money. In Nelson, little girls would get two wooden hoops and wrap them with coloured crepe paper, and fasten tiny orb-shaped ornamental bells to their shoes. The Maypole would be simply a *'swill brush handle'* wrapped with coloured paper. The May Queen who was seated whilst they sang their song and did a *'few shuffles like a dance'*, sat on a buffet carried round for that purpose. One lady who was brought up in Barrow in the Ribble Valley recalls *'The Queen was the one who got to sit on the stool and hold the Maypole. The pole was always decorated with ribbons'*.

In Rochdale, the May Queens had a make-shift Maypole just like the Nelson example, which was a brush pole with coloured streamers of papers wrapped round it. The Queen of May was dressed in a white frock, lace curtain as a veil, a wreath of paper flowers. The money they collected was invariably spent at the local toffee shop.

In Clayton-le-Moors they sang:

*All around the Maypole merrily we go,*
*Tripping, tripping lightly, singing as we go,*
*All the merry pastimes on the village green,*
*Sporting in the sunshine, Hurrah for the queen*

*[Queen sings]*
*I'm the queen, don't you see,*
*Just come from the meadow lea,*
*And if you wait a little while,*
*I will dance you the Maypole style*
*Can you dance the polka?*
*Yes I can, not with you but my young man,*
*First upon your heel, then upon your toe,*
*That's the way the polka goes,*
*That's the way the polka goes.*

*Around this merry Maypole,*
*This live, long summer's day,*
*For gentle Jen-ny Coo-per,*
*We've crowned the queen of May*

## MAYOR-MAKING IN CLITHEROE

A special Clitheroe Town Council meeting, closed to the public, is held roughly four weeks before the formal Mayor-making Ceremony. The Council in days gone by, locked themselves into a room and did not emerge until a new Mayor had been elected. A basket was lowered and filled by the local fishmonger with cockles and mussels traditionally from Morecambe Bay as fayre for the Councillors. The meeting is still held as the occasion demands to prepare the agenda for the Mayor-making, the councillors nowadays having a meal after the meeting usually of sea-food, of which the first course is still of course, cockles and mussels.

*Mayor-making, Clitheroe*

The Clitheroe Town Mayor is usually installed on the first Tuesday in May. Following the formal meeting of installation, the Mayor then leads his Corporation and guests through the streets of Clitheroe. The

procession is headed by two horses, two halberdiers carrying halberds, the Town Sergeant, the Mayor and Mayoress, Chaplain and Town Clerk, Councillors and their wives, the Ribble Valley Borough Council Mayor and Mayoress, the local member of Parliament, followed by civic guests and friends.

The procession makes its way to an appointed place for a meal and refreshment. At the end of the meal, the Town Sergeant leaves, taking the mace with him, the halberdiers leaving at the same time to put on their official robes.

After a short break the halberdiers return with a Loving Cup, a Colts Cup and the Aspinall cup.

These cups are then placed on the table in front of the Mayor and toast-master then states:

*'In accordance with ancient custom the next toast will be to The Corporation, that is the Mayor and councillors of this town of Clitheroe, the successor council to the second oldest Borough in the original county of Lancashire, and one of the oldest in the country. The ancient form of ceremony, as observed by past generations, with the quaint wording by which the toast is customarily proposed is due to be repeated. The Loving Cup contains punch brewed from an old recipe which has stood the test of time, Ladies and Gentlemen please be upstanding for the punch'.*

At this point, the Town Sergeant enters in his robes, carrying the mace, and walks down the centre of the room followed by the head waiter carrying the punch bowl. The Town Sergeant lays the mace on the table in front of the Mayor and the head waiter places the punch on the table in front of the mayor, the toast master then asks those present to be seated.

The Mayor stands and ladles punch into the loving cup, the colts cup and Aspinall cup and hands the loving cup to the Town Sergeant, who takes it in both hands. The Town Sergeant then says *'Mr Mayor I claim the privilege of proposing the time-honoured toast of Prosperation to the Corporation'* – then each person individually on the top table, repeats the toast and sips from the loving cup.

The Toast master then says *'I now invite all colts, that is ladies and gentlemen who are attending a Mayormaking in this town for the first time, to stand and they will be attended to in turn by the Town Sergeant and*

*halberdiers and invited to repeat audibly the toast Prosperation to the Corporation and drink from the cup'*. The head waiter then withdraws with the punch-bowl, and serves the punch into wine glasses which the Town Sergeant and halberdiers then serve to everyone. They then withdraw to take off official robes.

The toast list then continues. The Town Sergeant *'claims his right'* to present a toast to the *'colts'* – those present who have never attended a Mayor-making. The term *'colts'* seems to be derived from the common English dialect word which means *'an inexperienced or newly arrived person'* and possibly referred originally to new members of the Corporation.

A similar choice of words is recorded as being said when the burgesses of Much Wenlock in Shropshire were being installed, the dictionaries describing *'prosperation'* as obsolete and dialect only, by the end of the 19th century.

# 4

# WHIT WALKS AND CHRISTMAS

## WHITSUNTIDE

Whitsuntide was originally observed as a church festival, with merriment and festivities. Whit-week, as it is known throughout Lancashire, used to be a time for a general holiday in Manchester and Salford. This may have come about because of the annual race-meetings held at Manchester, which were a great attraction to old and young alike, who would have picnics and other celebrations in the nearby fields.

The extension of the railway system in the 19th century, led to the growth of popular seaside resorts of which Blackpool is probably most famous. Special excursions were laid on for the benefit of Lancashire workers at Whit, who for the first time, were able to travel as far as afield as North Wales, the Lake District and even the east coast.

For those unable to take advantage of the railway system, there was always some enterprising person who would operate locally. On the Manchester, Bolton and Bury Canal 'scholars' were taken by canal boat to Giants Seat at Ringley Woods, finishing at Owd Margit's Gardens on the side of a then acceptable River Irwell. Other canal trips included Sunday school scholars being taken by canal boat to Dunham Park along the Bridgewater canal, and along the Macclesfield canal from Ashton-under-Lyne.

Carts and lurries had seats added and local trips to a nearby beauty spot would take place. For example, there were trips to Ashworth valley from Bury and Rivington from Bolton and Horwich.

Women went into *'town'*, shopping in Manchester, looking in the shop windows. In fact, it was for many years known as Gaping Saturday for this very reason.

## WHITSUNTIDE PROCESSIONS OR WALKING DAYS

On the 28th January 1801, it was decided at a full meeting of St Ann's Church in Manchester, that all the church Sunday schools in Manchester and Salford should meet in St Ann's Square at Whitsuntide to hear a sermon and Divine service. It was intended that the service would be held in the St Ann's Church but in the event, presumably on the grounds of space, it was changed to the collegiate church which is nearby.

On Whit Monday, 6th May 1801, the procession marched six abreast. The Boroughreeve and chief constables went in front, followed by a regimental band. Reports vary on the actual number of children taking part from 1800 to around 2500 children, every Sunday school teacher after the service being provided with cheese and bread. The following year, the allowance was changed to *'dinner and a quart of ale each'*, this however was quickly changed when a teacher was found to be drunk and disorderly in the old churchyard!

Instead it was ruled, *'every teacher should receive one shilling and an additional sixpence to the master or mistress'*. In fact, the children received a penny bun before leaving St Ann's Square.

During the 19th century, the numbers attending 'walking day' increased, by 1834 there were 4000 children taking part and by the turn of the century it had risen to over 25,000. Eventually, the procession started from Albert Square, making its way through the city to the collegiate church. The processions were not confined to Church of England Sunday Schools, as the Roman Catholics also held a walking day on the Friday after Whit Sunday.

Whit Walks became firmly established and in many of the Lancashire milltowns long processions were organised for 'walking day'. Whit Friday was an event to look forward to with great excitement. Various church Sunday schools marched through the town or village accompanied by a mandatory brass band. Often the Rose Queen would feature in the procession along with her attendants and pages. Men would struggle to hold aloft in the wind a colourful banner, carrying some appropriate biblical message, or church name.

*Whit Walks, Rochdale*

In my own memory of Whit Friday the procession was led by choirboys carrying a banner or sometimes children carrying posies of flowers. Next would come the Rose Queen and her retinue, the retiring queen with her retinue, then sometimes a brass band, men carrying the banner aloft, boys holding the tethering ropes, and girls the back strings, then brownies and guides followed by the congregation usually led by the vicar.

In some places, coins were thrown to the participants from the watching crowds, or simply handed discretely to a person as they passed by. In Manchester, the processions were actually applauded, something that did not seem occur in other towns. Mothers made dresses for little girls,

little boys forcibly had their hair combed, and everyone was in their Sunday best. Poverty in the 1920s and 1930s was widespread, and it was often the only time in a year when a child might actually get some new clothing or shoes.

Whit Walks, 1905-10

A lady from Haslingden recalls *'I only ever walked once, my mother spent all her money on long white stockings and white canvass shoes and if it rained – they were only made of cardboard – all the bottoms come out. I can remember I had this white lace dress. It were lovely. I had a crook, like a shepherd's crook and they put a bunch of flowers on the top you see and you'd ribbons hanging down. I had a blue straw hat, with blue ribbons. After walking day mi dad made this row, "spending stuff on that when we want this" and it spoilt everything. It was the only time I ever walked because we had no money.'*

An old lady from Moston recalled Whitsuntide when she was a girl around 1903:

*'It started Whit Sunday. I went to St Luke's at Moston, on the Sunday we just*

*walked all round the parish and then Monday, was a day in the fields and we had 'bun and nuts' and they used to take great churns of milk and we used to get milk and a currant tea-cake – with no butter on.'*

*On the Tuesday we might have a railway trip to Saddleworth or Smithy Bridge, just little places outside you know.*

*Our mothers used to be down at the market at 6 o'clock, Whit Friday morning, because you used always have a basket of flowers and I used to walk with a little girl, Eva, she was called, our mothers used to try and get us under the banner, we both dresses alike, of course we would only be about 4 or 5 then.'*

*At Friday we used to all assemble outside the school, brass bands you know and we'd Walk all up Moston Lane and right up Nuthurst road, and it was all fields then. Oh Lovely with buttercups and daisies. Then we'd go in St Mary's church for a service there and then go back to the school and have a sit-down tea.'*

In Nelson just prior to the second world war, they even borrowed a coal cart for the Whit Walks.

*'You borrowed a coal cart, you got it on the Saturday, it was cleaned out and decorated. Then you borrowed the hassocks from the church, and then the coal-driver used to bring his horse, it shone, plaiting, the braid on its mane, brasses, the coalman walked all the way leading the horse. You went from your parish to a central place led by the Salvation Army Band and the Sunday school teachers walked with the children. The little children were on the hassocks.*

*You got your best things on, you'd always try to get new things, a white or place blue dress, straw bonnet decorated with paper flowers, white socks and shoes. Afterwards we went back to the school for a kind of spiced biscuit and tea.'*

In Accrington the Whit Walks were considered a time for pleasure as well as religious witness. *'On Whalley road between Clayton-le-Moors and Accrington, all the shops had stalls outside. There were men walking about and they had a little stall they carried. There were all sorts of things on elastic, little monkeys, balls, fancy hats and I can remember some little walking sticks. It were like a tray, with all these things hung on at the back, with being on this 'lastic they bobbed about.'*

In Manchester, the processions were enormous, eventually taking place over several days. It could take almost three hours for a procession to pass a particular point, but with the decline in inner city populations, church closure, and increased traffic, where walks still survive they are a

shadow of their former selfs. In Sabden near Pendle Hill the local church still processes around the village with a brass band, much in the traditional way.

Whilst on the subject of bands, one lady recalled that *'My dad being a church official used to go to the railway station. The bands used to come on the train and he used to go and meet them and walk in front of them down to the chapel. The bandsmen used to have breakfast at Sunday school. And we walked all round Mossley and they went back to school for their lunch.*

*Then, there was a great band contest on Mossley Brow outside 'The Britannia'. All the crowds were there, all the traffic was held up, lorry drivers were fuming because they couldn't get through.'*

Town and city walking days needed considerable organisation to ensure that each church fitted in exactly. For example, a distant church might have to start their longer walk well before the other churches, in order to meet up with the main procession.

After the walks were completed, and the children were dropping on their feet, the procession ended back at the church or Sunday school. Sometimes there was a short service in church, but almost always there were sticky buns and coffee. In some place there were games and other festivities in the afternoon usually held on a nearby field.

At Warrington their Walking Day as it is known, takes place on the 1st Friday in July. Doubtless inspired by Manchester's example, the Walks were introduced as a counterblast in 1832, to the somewhat dubious attractions of a local horse-race.

A lady from the village of Croft near Warrington fondly recalled that *'... and all the churches parade and it takes that procession I would imagine about two hours to go past.'*

## ORANGE LODGE PROCESSIONS

Although Whit Walks were not held in Liverpool, around June there were processions for the various Orange Lodges. A lady recalling the 1930s recounted *'They went for an annual day out. Everybody went when they knew it was the Orange Lodge Procession, they would line the route right the way through to the station, where they went on to Southport. Even before the actual procession, each different Borough say, Bootle or Litherland, they'd*

*have the May Queen's dress on show. It would be all displayed in a window where you could go and have a look at this regalia.*

*The procession would have a banner bearer, then all the different bands and committees from the different lodges and the people who were from the Lodge and then the Queen and her attendants. Then there were all the horses, they were judged when they got to Southport.'*

## ROSE QUEENS

Some Lancashire churches had Rose Queens. She had to attend that particular church and presuming that she had been a regular attender at Sunday School she was eligible for the position of Rose Queen. The Rose Queen for the year took part in the Whitsuntide processions and was crowned later in the year. One of the Rose Queen's official duties was to open the Christmas Fayre with a speech.

## THE KING AND QUEEN OF DOWNHAM

On Whit Tuesday at the Downham Wakes, a King and Queen were elected for the day. The position of Queen always fell to the lot of the prettiest lass in the village, a committee of young men making the selection. An iron crown was then dressed in flowers. They were adorned in the costumes of Royalty and ornamented with flowers and the crown was carried before them in procession headed by a fiddler. The procession went from the front of presumably what is now the Assheton Arms Inn to nearby Downham Hall and was composed of javelin men and all the usual attendants for a Royal occasion. Chairs were brought out of the Hall for the King and Queen and ale was handed round. A dance was performed on the lawn, the King and Queen leading off.

The procession then headed back to the village green where seats were provided. There was then general gaiety with games and dances. On the next night the King and Queen invited all the young people to the Inn each paying a shilling towards the Queen's Posset which was handed round and consumed by the company.

## OAK APPLE DAY

On the 29th May, it is recorded that it was customary to decorate the pinnacle of the church tower in Flixton with oak boughs. The church

bells being rung in celebration. The origins of this peculiar custom go back to the days of King Charles II. On 29th May 1660, following the English Civil War, Charles returned to London. Parliament decreed that the restoration of the Monarchy was to be celebrated annually with church services, bell-ringing and bonfires. The wearing of an oak sprig or oak apple became an important symbol; this may recall when the King hid in an oak tree to avoid Parliamentary troops after his defeat at Worcester in 1651.

## EMPIRE DAY, 24th May

One day to remember on the school calendar was Empire Day. In some schools, there were special lessons to remind children how wonderful the Empire was and to instil a feeling of pride. An Oldham man recalled: *'We still had an Empire when I was at school and everybody was proud of it and you were taught – or brainwashed – at school into being proud of this Empire. It was only the Empire for the rich in my opinion, but we were proud of our history, of the achievements that had been done in the past years. Some of the church schools had children dressed up as John Bull, Indians, and so on.'*

*'When we went to school we used to have a little bunch of daisies 'cos that's the emblem for Empire Day and you had a little bit of red, white and blue ribbon tied round,'* recalled one old lady. *'We waved little Union Jacks in the morning',* recalled one man, *'but the best bit was the holiday in the afternoon.'*

# JUNE, JULY, AUGUST

## ROGATION OR GANG DAYS

This is the Church of England's equivalent of Beating the Bounds. The Sunday before Ascension was Rogation Sunday, and on one of three days before Holy Thursday, it was customary for parishioners to visit the boundaries and limits of their local parish. The minister with his churchwardens, would say a prayer to preserve the order and rights of his parish. In fact the custom has not quite died out, on the Fylde near Pilling, at Eagland Hill, they still go around the Parish on Rogation Sunday singing in *'each of the local farmyards'*.

## BEATING THE BOUNDS IN LANCASTER

The custom of beating the bounds is not peculiar to Lancaster, it was widely practised in Scotland and also at many places throughout England. In the days before accurate maps were available, it was necessary to perambulate the boundaries of the parish or estate. At marker stones and other obvious boundaries, a child might literally be beaten or struck to make sure they remembered where the boundaries were in the future. In some places children were less painfully treated, but up-ended amidst a lot of laughter, in others they were *'cheerfully chucked'* into nearby nettles to *'remember'*.

*Lancaster: Beating the Bounds*

In Lancaster in 1788, the Mayor and Company took matters very seriously indeed. In times past they were reported to have *'whipped a number of boys or ducked them in the water . . . so as to give them cause to*

*remember the exact position of the boundary, the same boys afterwards being sent home with half pence in their pockets.'*

The Company assembled at the Town Hall at 5 o'clock in the morning, leaving at six, the procession being headed by a Fife and Drum Band. Some 12 hours later, they returned from a tiring 26 miles of boundary tramping. Up to 150 horsemen and 1500 pedestrians were reported to have taken part in the tradition of *'boundary riding'*. At the end of the 18th century, the tradition became associated with festival parades of the Friendly Societies in Lancaster who met the returning horsemen and with regalia and banners formed a grand procession.

In Victorian England, civil formality took over, the procession being quite formal consisting of:

Pioneer mounted with all the implements necessary for the removal of any obstructions in the boundary.

PC Wright with colour – unmounted

PC Proctor with colour – mounted

PC Nicholson Town Sergeant, with colour – mounted

Superintendent Wright mounted

W Dunn Town Clerk, mounted, having -

T Johnson Magistrate's Clerk

Gardner Mashiter Mounted on the right

Treasurer mounted on the left

The Mayor, H. Gregson, Mounted

With his Aldermen mounted at his side.

Followed by the Corporation and Gentry, two and two, horsemen, burgesses etc.

*'Before 9 o'clock, rain began to fall and as the day passed it became extremely wet, nevertheless a goodly array of horsemen assembled . . . and Market Street was early blocked with an anxious and expectant crowd of pedestrians. The Mayor, ex-Mayor, and Alderman rode in a carriage.'*

The strict civic order was not however followed in later years. The Mayor for example, met the party at various pre-arranged points and in

1928 it was reported '*that Chief Constable Harriss would be using his car instead of a steed*' and that the Town Crier would be accompanying the party.

Mr Fred Smith the Sanitary Inspector, and flag-bearer made his sixth perambulation, leading the way through thick and thin.

This particular day was not without its misadventure: '*Mr Thomas Patterson, son of Mr Councillor Patterson received a compound fracture of the left leg . . . Mr Patterson ran into a lamp-post opposite Ripley Hospital. He recovered.*'

The procession in the 19th century left the Town Hall in Lancaster through Cheapside, to Germany Bridge where the first proclamation was made. From there to the end of Ladies Walk, the going became difficult here for those on foot and a boat was provided to go down-river to the far arch of the Lune Bridge on the Skerton side. The boat then went up the middle of the river as far as the ford, the horsemen going along St George's quay to Scale Ford where they crossed the river. From there, they went along the river to near Snatchem's where they would cross the river to Marsh Point Wood and from thence to Freeman's Wood to the Herring Stone on the hill. The Lune is, of course, tidal and there are accounts of the Flagman having to drag his boat along the bed of the river because the tide was out. It is not recorded what happened if the tide was ebbing or flowing.

The river also has extensive mud flats and, in 1893, it is recorded that: '*Having nothing better to do, the crowd interested themselves in the horsemen and especially in speculation as to how they would get across the river – the tide being very low. Ultimately, Mr Baxter led the way and Mr Smith followed. Both crossed the stream easily enough, but as soon as the horses attempted to traverse the soft mud of the bank on the Lancaster side, they began to sink, and their struggles to extricate themselves only resulted in their sinking deeper and deeper. The riders jumped from their saddles, and scrambled through the puddle to firmer ground. A number of men started collecting armfuls of straw and seaweed that had been left by the tide, and after a considerable quantity of this had been strewn on the soft slimy sludge in which the horses were floundering they were able to find some foothold.*'

From there '*along the brook in Mr Dawson's land to his lodge*', and then on to the Lancaster canal which was crossed by boat. The next place was a well '*on Mr Johnson's farm*', then to number 7 Pointer Houses, and on to the trough at Pointer where the Proclamation was read again.

The proclamation would be shouted out *'Oyez, Oyez, Oyez! This is the boundary mark of the Borough of Lancaster known by the name of . . . God Save the King!'*

Assuming this wonderful civic sortie was still intact, they then proceeded to a garden in Bowerham Lane to St Patrick's well, on to Golgotha, and Wolf's Well and at last lunch which was provided at the Grand Stand. After lunch, there were races on the race-course for *'gentlemen riders'*. If the party had any energy left or the will to continue, they proceeded to Grab Hall, across the Moor to Stanley Wood End, Bulk Bottom and across the Lune into Ridge Lane, through the centre of the brook near the dry dock on the canal and back to the starting point. They were then marshalled back to the Town Hall, where it was reported *'there will be an abundance of good things provided, to pass off the remainder of the evening.'*

By 1956, there were only four horses taking part, all mounted by policemen. The Corporation had succumbed to temptation and a bus was used to convey members and officials of the council. The spectacle was witnessed by a group of Canadian tourists, temporarily halted on their coach, the BBC also being present filming, *'adding interest to the early proceedings.'*

Over the years, not only did the nature of the custom change but of course so did the boundaries. In 1963, it included the site of Lancaster University for the first time, and in 1984, another change, this time the boundary men were accompanied by the John O' Gaunt Morris Men.

The old town boundary was hard enough, but the new Lancaster City boundary covers a far greater area. The Beating of the Bounds held in 1984 was a revival by the John O' Gaunt Morrismen who danced at certain predetermined points around the City's new boundary. They started at the Trough of Bowland at 8.30 a.m., going by way of Abbeystead, Dolphinholme, Cockerham, Lancaster Town Hall, Silverdale, Yealand Redmayne, Priest Hutton, Whittington, Ireby, Cantsfield, Wennington, Great Stone of Four Stones and on to the Cross of Greet high on the Moors above Bentham on the Lancashire and Yorkshire border.

# THE LANCASHIRE WAKES

The Wakes holidays of Lancashire and Yorkshire, probably have their roots in the religious wakes which accompanied festivals and Saints' days. The eve of a particular anniversary of the founding saint of a church was a time of watching or a wake. In some churchyards, booths were erected and there were feasts, dancing and other delights which continued throughout the night. The celebrations often quite rowdy and eventually they were transferred from the churchyard to the village green or marketplace. These feasts or wakes gave rise to the annual wakes holidays.

By the 19th century, the annual Wakes were playing a somewhat different role, giving ordinary working people the chance to get away from the mill or workplace for a week or so. Often the celebration of the Wakes was accompanied by fairs and markets and with the coming of the railways, towns like Blackpool and Morecambe developed to take the visitors.

The Wakes weeks were traditionally staggered over several months. For example, Bolton holidays originally started on the last Saturday in June, whilst in nearby Bury, Wakes was from the first Saturday in July. These wakes were also known as cotton town holidays, when entire cotton producing areas would stop production for at least a week.

A man from Nelson recalls *'They had quite big railway yards there and they had trains made up ready, one for Torquay, one for Bournemouth, this was just after the war, this was on the Friday night.'*

At Didsbury Wakes near Manchester in 1825, before the coming of the railway, there was a Wakes Fair with *'ass-races for purses of gold, grinning through collars for ale, foot-racing, treacle loaf eating, apple-dumpling eating, as well as country dancing'*.

The Eccles Wakes was held on the first Sunday in September and lasted for at least three days, in which Eccles cakes were consumed in great numbers. There were *'sports'* of various kinds including bull-baiting for a horse-collar, donkey races for a pair of panniers, *'to conclude with baiting the bull 'Fury' for a superior dog chain'*. On the Tuesday, the sports were repeated with some variations, including cock fighting with a twenty guinea prize. *'The wake was concluded with a fiddling match for a piece of silver.'*

In the Fylde, galas were held. Galas were certainly associated with the church but they also seem to have had an association with the Marling Celebrations. The Staining Gala is perhaps one of the most well-known, as a local lady recalls *'It was beautiful. I can remember being on the farm, all the farms around and everybody joined in. The farmers used to take it turn to give a field and the whole field used to be decorated and they had steps up and big platform and they was magnificent and all draped round with beautiful bunting. Every child was something, either a Rose Queen from this year, a Rose Queen from last year and she had six attendants, and you went down to every child. There must have been over a hundred people dressed up in magnificent, beautiful dresses and the boys were in white shirts and satin pants. Every girl carried a garland as well'.*

Another lady recalls *'On a certain Saturday, every village had a gala in turn, especially in the summer months around July. You'd get all the Queens moving round from Gala to Gala with all the decorated banners. Sometimes they had a waggon decorated with paper flowers. From that you had a carnival of queens at Blackpool. There was also a fairground that came as well.'*

## WESTHOUGHTON KEAW-YEDS

In Westhoughton, the Wakes were traditionally held in August, the actual date being hotly disputed by the locals for many years. Some said it started on the 25th August, the Sunday before Saint's Day, although today, it is generally accepted that it commences on the Sunday on or after St Bartholemew's Day.

In Westhoughton the wakes were a time for fun. Silcock's fair came to town with its dodgem's and waltzers, and in the 19th century there were shooting saloons, stalls with gingerbread, swings, aunt sallies and on one occasion an exhibition of *'moving waxworks.'*

Westhoughton Wakes however was famous not for its aunt sallies, but for the story of the Cow with its head stuck in the gate.

The story goes that many years ago an unfortunate cow, got its head stuck well and truly between the wooden bars of a farm gate. The farmer, looked at the problem, grasped the bull by the horns so to speak, and twisted its head in order to release the animal. He struggled in vain, eventually deciding that the most practical way to solve the problem was to cut off the cow's head, which he did.

The Cow's head or *Keaw-yed*, played an important part in the annual wakes. Families would traditionally have a meal of potatoes, onions and 'cow's head' – a dish made with a thick crust of pastry. After the meal, the head was cleaned and bleached ready for use the following year at Wakes time. 'Bone Clubs' arose, rival groups carried heads and collections of bones on poles, sometimes decorated with ribbons and paraded them through the streets to various public houses on the Wakes Monday.

Many public houses displayed a specially decorated cow's head. In recent times, the Red Lion Hotel even arranged a tableau with a full-size gate and cow's head projecting through it, people coming from miles around to see it.

The tradition led to the making of '*keaw-yed pies*' and pasties. One firm in the 1960s made about 900 pasties using 60 lbs of flesh. In the 1880s they even had a giant pasty some four feet by two feet, displayed in the window of a local confectioner.

It seems likely that the true origins of the keaw-yed story have been lost. One theory points out that, in times gone by, a '*method of killing the sacred bear*' was to place its neck between two poles which were violently compressed; the origins may go back to those times. Another suggests that it was connected with St Bartholemew's Day when the celebrations at Westhoughton were held. St Bartholemew being the patron saint of butchers. Certainly the eating of flesh seems to pre-date the keaw-yed-in-the-gate story. One tale suggests it all started when following the Battle of Waterloo and Napoleons defeat, some of the well-to-do of Westhoughton gave a cow to be publicly roasted. The roasted animal was for all including the poor.

A procession, with the cow's head on top of a pitchfork, is said to have marched though the streets towards a district of the town known as '*Lowside*'. There was rivalry between the two groups and the cow's head was probably waved as a taunt. An attempt was made by the Lowsiders, to grab the cow's head. There was a general melee and confusion in which the head was almost lost to the opposition, the day only being saved by reinforcements in the form of the womenfolk of the Chapel Moorers. The victors soon became known by the Lowsiders as '*keaw-yeds*' and over time, the name was applied to all Westhoughteners.

## RINGLEY'S MOCK MAYOR

How do you fancy being Ringley's mock Lord Mayor for a year? You do! Well, there is a slight catch, namely that it is no longer performed and when it was, the Mayor got exceedingly wet.

How the custom of the Ringley Mock Mayor arose is uncertain, but a Lord Mayor was *'elected'* for the year and duly dressed up for the part, complete with trident.

The ducking took place on a Monday night following the Wakes, *'you'd a job getting down Ringley for people watching it. They used to take him round on this like a table to carry him, of course they used to rest on the way, then bring it to the back of 'The Horseshoe'.*

*He was dressed up with a jacket with braid on, but he'd ordinary trousers on and a tallish hat, a top hat, and in his hand he held a fork (trident) with a piece of toast on. That was his symbol.*

*Every Sunday after he was elected Lord mayor, he could go down to the pub, Stoneclough, and give his card, and they gave him a free pint. So long as he had been to church . . . in the old days one Lord Mayor used to come to church on horseback, he'd tie it up against 'The Horseshoe' until the service was over.'*

There is even a set of regulations that the Lord Mayor must obey, they are as you might suspect, none too serious. For example:

*'. . . if the Lord Mayor goes home drunk and his wife turns him out, and if he has nowhere to go, then – if he sees three pigs asleep on a midden he can stand to drive the middle pig out and lay down in the warm place beside the other two, and woe be to that man, if he resides within the boundary of the Borough of Ringley, who dares dispute his Worship's authority'.*

The Mayor's procession was headed by a fiddler dressed in gay ribbons. Starting at the *'Horseshoe'* the procession went on to the *'Three Crowns'* and across the bridge to the *'Lord Nelson'*.

The Lord Mayor received a shilling and a jug of ale at each of the public houses, before being carried across Kearsley Moor, Stoneclough and back again to the Lord Nelson calling, of course, at every pub on the way. By the time he reached Ringley, he was unlikely to be of a sober and upright disposition, and a practice of dunking him in the river or canal (which was also close at hand) grew up.

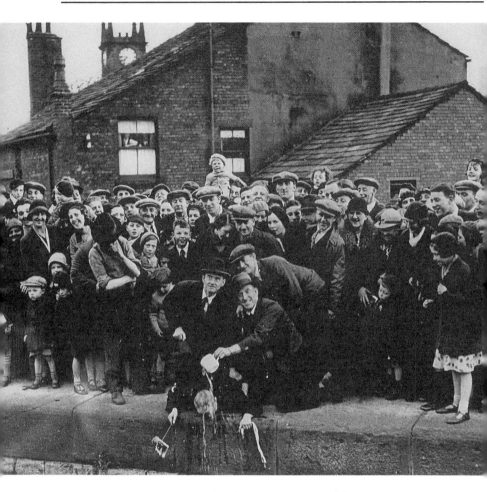

*Ringley Mock Mayor celebration*

Alas the custom has died out, possibly because the canal has long been filled in and the waters of the Irwell are none too tempting even to the inebriate.

## THE GUISING WAR AT ECCLES

Just like Ashton-under-Lyne, guising or gysing was celebrated in the Eccles area, following marling on the field. The villagers with a King at their head formed a procession with garlands to which silver plate was

attached, contributed like the Ashton guising, by the well-to-do of the neighbourhood. The object was to excel in the splendour of the procession. An account published in 1778 by a Mr William Ford is worth quoting in some detail as it describes the incredible rivalry that once took place between neighbouring towns and villages.

*'Mr Chorlton of Monks Hall, had some men getting marl and it being the custom . . . for some of the neighbours to give . . . to these men to drink . . . which enables them to go to that hard labour with cheerfulness . . . Some few young people of 'Catch Inn' made a small garland . . . and on Friday June 13th 1777 carried the garland to the marl pit and made the marlers a present of it, with 3 shillings and 6 pence.*

*In the evening the marlers brought the garland into Eccles, it excited the curiosity of the young people (there) to know by what means they got it. It was thought by the young people of Eccles an insult as they belonged to the town of Barton-on-Irwell, the marl pit belonging to the township of Eccles.'*

Intense rivalry resulted. The marl pit was taken possession of by guisers from Eccles and from Barton-on-Irwell, which the writer describes as *'a war between two great nations'*.

A manuscript found in Salford City Archives summed up the situation:
*Barton and Eccles they will not agree, for envy and*
*pride are the reason you see;*
*If Eccles has faults, Barton has the same,*
*Wisdom it will be not each other to blame*

The subscriptions both groups received grew and they held regular processions each trying to out-do the other.

By the end of September 1777, Barton-on-Irwell had 'collected' £687 – 1s – 0d and Eccles had 'collected' the amazing sum of £2242 – 1s – 6d. 'Collected' is however a misleading term, for what probably happened was that the 'silver' or expensive items would probably be lent for only an hour or so. The display of wealth from the gentry was carried on *'a big drum at the head of the procession.'*

The Eccles procession on the 14th July 1777 had over a hundred men and women with spikes and swords: *'some dressed up as Robin Hood and Little John, others as Adam and Eve in a single horse chair with an orange tree fixed before them and oranges growing thereon'* proceeded to Barton . . . *'with*

*drums beating, colours flying, trumpets sounding, music playing and about sixteen couples of Morris Dancers'.*

By the 1st September, the Eccles procession had more than 150 men and women marching to Pendleton Pole with a King and Queen at their head. *'Barton on the 24th September mustered about 220 men and women with 21 guns, cannons and muskets which began firing at 5 o'clock in the morning. With a bull at the head of the procession with bells round its neck they marched to Eccles. The Queen had 34 maids of honour, there were 20 couples of morris dancers, several bands of music . . . and a grand garland drawn by four good horses'.*

The last of these rival guisings that year was held on the 20th October when the Eccles procession numbered 216 horsemen and nearly 100 footmen, the Queen having 56 maids of honour in attendance.

The conclusion reached by the 18th century observer was that *'Barton was the first offender and assailant by invading Eccles with guisers; and that the victory remained with Eccles, which had only sought to defend its own property.'*

In the Fylde, the occasion was known as *'shutting of marling'* and had its own gala day. A *'Lord and Lady'* presided at the feast, having previously been drawn out of the marl pit by a strong team of horses, decorated with ribbons, mounted by their drivers and trimmed-out in their best. As the procession passed along the village lanes money was collected from bystanders and spent wisely at the feast.

## PINS AND WELLS

Near the old manor house at Brindle, *'there was a spring of very clear water, rushing straight upwards into the midst of a fair fountain, walled square about with stone and flagged in the bottom, very transparent to be seen . . . This fountain is called St Ellen's Well'.*

The writer of this historical account was somewhat anti-Catholic he says: *' . . . to which place the vulgar neighbouring people of the Red Letter (Roman Catholics) do much resort in pretended devotion on each year upon St Helen's Day (18th August) where out of foolish ceremony, they offer or throw into the well, pins which there being left, may be seen a long time after by any visitor of the fountain.'* A similar custom was practised at St Helen's Well near Sefton, where it is recorded that *'I have frequently seen the bottom of St*

*Helen's Well covered with pins, which I suppose, must have been thrown in for the like purposes'.*

## THE AUGHTON PUDDING FESTIVAL

The origins of this unusual tradition go back probably to the end of the 18th century. Robert and William Lamb, local basket makers, ordered a special boiler so that they could steam the willows and thus easily strip away the bark. When the oblong boiler arrived it was said to resemble a pudding, and thus the idea was born of using the new boiler to make a giant plum pudding as a kind of celebration. In this first effort, the ingredients took two days to mix, then it was placed in a large muslin sack and put into the boiler. The mixture was then boiled for five days and four nights until the pudding was ready.

Other 'Pudding Festivals' were organised over the years, the 1866 pudding weighing 300 lbs. The festival originally took place around Christmas time and the New Year, eventually taking place on the 3rd of January each year. The festival caught the Victorian imagination and in 1886 it grew much larger, with over 10,000 people attending from nearby areas.

The Pudding was also larger, being a hefty 1,200 lbs approximately in weight.

The month of July 1992 saw a special pudding festival, this time with a challenge. There was an air of frivolity and whole occasion was enjoyed by many. Accompanying events included the Kirkby Lonsdale Brass Band and a Big Bale Rolling Contest, the whole thing culminating in an official grand pudding weighing ceremony.

The mixing of the great pudding took place in the middle of a field. The ingredients included 9 gallons of brandy, 225 lbs of flour, 10 lbs of salt, 225 lbs of candied peel and 1.5 tons of dried fruit. A special cement mixer was used to mix it all together and the mass was cooked in a special boiler prepared by British Gas. It was hoped the pudding would provide about 30,000 servings.

Cheryl Baker from the Guinness Book of Records declared that the 1992 Aughton Christmas Pudding to be the largest in the world, weighing in at 7,190 lbs. The festival takes place every 21 years and attracts people from all over the world.

# AUGUST, SEPTEMBER, OCTOBER, NOVEMBER, DECEMBER

### RUSH-BEARING

Many churches in the early days had simple mud or earth floors. The floors were often covered with rushes, which are extremely durable and relatively warm to the feet in winter. The practise was not just confined to the church; many houses had earth floors, some even within living memory in the Pendle Hill area, and rushes would not only be pleasant to walk on but when fresh, aromatic as well.

Rush-bearing seems to take place at different times of the year according to the location. At Altcar for example, the rush-bearing was in July, in Barrowford and Rochdale it was August and even September in one or two places.

Rush-bearing became a major tradition for the local people, it was important all over Lancashire and it is worth recording it in some detail.

*Rush-bearing, Whitworth*

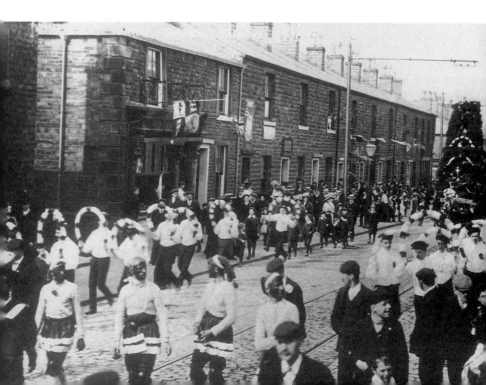

Some years ago, I was responsible for re-creating a Rush-bearing. First of all the right kind of rushes had to be located. Cutting rushes is particularly hard work even with a scythe, and there is a definite knack to cutting. The rushes are built-up on the rush-cart into a huge pile, in our case about 10 feet in height, and then on rush-bearing day the cart is drawn through the streets to the church with much celebration and not a little drink.

The rush-cart was often preceded by a large silk banner and decorated with flowers and ribbons. Often a young lad or young men of a somewhat sober nature were placed precariously on the top of the pile of rushes, hence the expression 'to be on the waggon'.

The story of the Radcliffe rushbearing is well documented in Rev Nicholl's 'History & Traditions of Radcliffe' where he says – 'On either side (of the rushcart) were the picturesque Morris dancers; then came the grove, surpassing the rush cart in its beauty of decoration, and carried by four flower-bedecked men. Under this canopy walked the queen of the festival. The lass chosen invariably belonged to the working class, but she did not lack beauty, showing that nature is impartial in her bestowment of her greatest gifts. Some of these were so persistently good looking that they held the place of honour for two or more years. Jenny Shem a laundress, was an instance of this; she combined beauty of face with dignity of figure and carriage.

The procession went on from there to Heaton Park where Lord Wilton, the lord of the manor of Radcliffe and members of his family and guests came out and watched. The dancers were regaled with refreshments and had a good time. Frank Pendlebury who headed the procession with stick and bladder was master of ceremonies. He was attired in white stockings and knee breeches, a dress coat with a green shade of cloth with brass buttons. 'This pageant of ancientry' was held on the first Saturday in September.

Saddleworth, on the borders of Lancashire and Yorkshire still holds an annual rush-bearing. In the old days, six or eight rush-carts met at church with their loads of rushes. Carts were sometimes accompanied by fife and drum, stopping at each house for suitable libations or gifts of money.

The Barrowford rush-cart attracted vast numbers of people from Burnley, Colne and Padiham, there were even cheap day trips organised by the railway. According to one account 'riot and drunkenness reign supreme'.

In other places such as Downham, there were more sober occasions, Rush-bearing being observed on the Sabbath. Rush-bearing is still observed at Newchurch in Pendle, although the rush-cart is no longer used.

In the early days, rush-bearing was a much more sober affair in more than one sense. An account dated 1825 says, *'I was told by an old man, now deceased, that he remembered the rushes to have been borne on the shoulders of the country people in bundles, some very plain and others ornamented with ribbons, garlands etc., to the churchyard in Rochdale'.*

*Rushbearing, Rochdale*

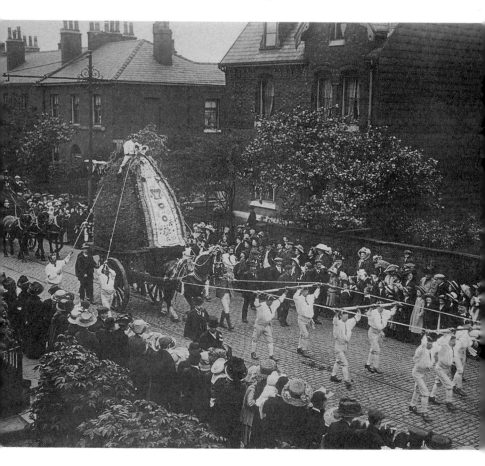